IMAGES
of America

OKLAHOMA CITY ZOO
1902–1959

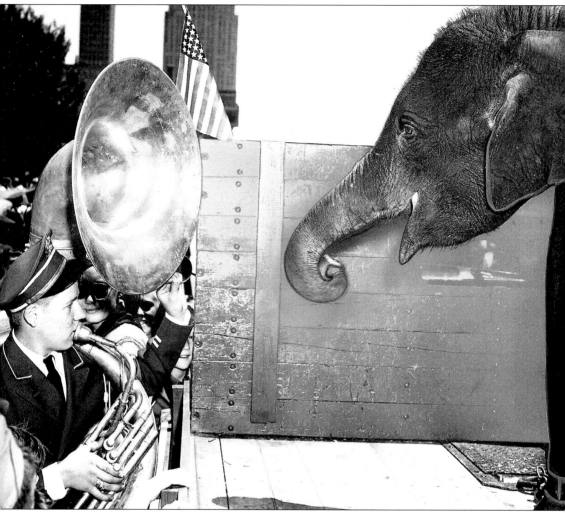

This book was inspired by the story of Judy the elephant. She was purchased with money raised by children in 1949 and was the zoo's favorite animal of all time until her passing in 1998. (Copyright 1949, the Oklahoma Publishing Company.)

On the cover: Please see page 107. (Copyright 1951, the Oklahoma Publishing Company.)

IMAGES
of America

OKLAHOMA CITY ZOO
1902–1959

Amy Dee Stephens

ARCADIA
PUBLISHING

Published by Arcadia Publishing
Charleston, South Carolina

Printed in the United States of America

Library of Congress Catalog Card Number: 2006923708

For all general information contact Arcadia Publishing at:
Telephone 843-853-2070
Fax 843-853-0044
E-mail sales@arcadiapublishing.com
For customer service and orders:
Toll-Free 1-888-313-2665

Visit us on the Internet at www.arcadiapublishing.com

To Ernie Wilson, who has spent his entire career at the Oklahoma City Zoo pulling things out of the trash in which no one else saw value. Without him, irreplaceable history would have been lost forever.

CONTENTS

ACKNOWLEDGMENTS

Special thanks to Oklahoma City Zoo director Bert Castro for having vision for the zoo without forgetting the importance of its past; to my parents, Marvin and Phyllis Davidson, who gave me drive and then could not keep me from "burning the candle at both ends"; to my supportive husband, Michael Stephens, who patiently watched me burn the candle every night. I have so many other people to thank for helping out with this book along the way. Photographs were provided by Ernie Wilson, Karen Jones, Pearl Pearson, John Dunning, Wes and Lori Allen, the Oklahoma Metropolitan Library System, Teresa Schaefer, Mary Phillips at the Oklahoma Publishing Company, and Terry Zinn at the Oklahoma Historical Society. Editorial assistance was provided by Phyllis Davidson, Dr. Ken L. Brown, Todd Bridgewater, Barbara Ebert, Lizabeth Ogle, David Walker, Walt Hartig, Holly Walner, Stephanie Shafer, Greg Zornes, Lynn Brown, Kevin Seldon, Alan Tripp, Toni Palmer, Presiyan Vasilev, Jennifer Latham, Francie Helm, John Poling, Rebecca Windle, Rebekah Nichols, and Dustin Sliger. Research was conducted by Barbara Fragos, Joe Fox, Barbara Williams, Sandra Dean, Ina Jones, and Thane Johnson. Computer assistance was provided by Cliff Casey and Jay Tracy. Administrative support was provided by Dr. Allison Brody, Teresa Randall, and, of course, the Oklahoma City Zoo.

INTRODUCTION

But whether we love them, are amused by them or simply find them fascinating,
the fact is that animals have something to teach us all.

—Herb Clement, 1969

Walt Disney said, "It was all started by a mouse." The Oklahoma City Zoo started with a single deer. F. M. Morris donated this first buck to the newly created Wheeler Park in 1902, five years before statehood. More wildlife followed, until a fairly large menagerie resided at the park. On September 7, 1903, James B. Wheeler, a prominent banker and donor of the site, formally dedicated the park and its zoo during a huge Labor Day celebration. The *Daily Oklahoman* newspaper claimed that no park in the country had assembled such a large zoological collection in such a short time. Although Wheeler Park still exists, the zoo relocated northeast to its current location at Lincoln Park in 1923. The name Lincoln Park Zoo was later changed to Oklahoma City Zoo, and again in 2001, it was changed to the Oklahoma City Zoological Park and Botanical Garden.

It is fitting to pay tribute to the animals that made the zoo such a success in the first place. This photographic journey through the zoo's history is largely told through the stories of the bears, elephants, and other animals that gave this midwestern zoo such flavor. The development of the zoo, and even the state, unfolded as the animals played out their very public lives before an audience of Oklahoma citizens. The apparent bonding that took place between animals and people created a strong community atmosphere in Oklahoma City. Animals brought joy to the visitors who sought escape from the daily grind. In turn, the creatures inhabiting the zoo were affected by world events, economics, and the staff personalities that surrounded them.

Although some people today would debate whether zoo animals should be labeled with personalities, in the early to mid-1900s, associating animals with humanlike characteristics and feelings was openly practiced. Since most information about the zoo's inhabitants was shared via newspapers, the writing style and attitude of the journalists largely shaped how the public viewed these animals. The act of projecting human qualities upon the animals—love, joy, loss, sorrow—caused people to relate to them. Those with familiar names, who seemingly showed feelings or encountered humanlike situations, appeared in newsprint frequently.

Each era's social trends and the park's philosophy influenced the way the media portrayed the zoo. From the 1900s to the 1920s, newspapers were largely social columns. Articles about animals in the *Daily Oklahoman* focused on the everyday life of park residents and were often written in a chatty style. For example, the love life of Ida the ostrich was a frequent feature; she was lonely, she was in love, she wanted children, she was barren.

During the 1930s, a much-touted circus performer, Leo Blondin, became the zoo director. He masterfully created performance-type situations to attract the media. Luna the elephant, who took baths in the lake and paraded through town, often drew attention in Oklahoma newspapers. The qualities she apparently shared with humans, including a chronic toe infection, caused Luna to be seen as an interesting character. Under Blondin's leadership, coming to the zoo resembled attending a circus show, with animals and visitors interacting together, chimpanzees wearing bow ties, and children riding camels. This circuslike atmosphere continued into the 1950s under the leadership of zoo director Julian Frazier.

Another reason people attached such powerful memories to certain animals was because of a specific incident that merited notice. For example, the three-day escape of Leapy the leopard in 1950 made headlines around the world. Onlookers who were part of the event used strong words to describe the emotions they felt that day: excited, fearful, and terrified. This childhood event left a lasting impression on Anna Myers, author of *Spotting the Leopard*, a 1996 juvenile novel based on the escape. More than 50 years after the event, she recalled her true-life memory of the incident. "Looking back," she said, "it seemed like we were in terror for weeks, not just three days!"

Gone are the circus days of chimpanzees in clothing. The modern zoo no longer functions solely as an arena for entertainment. By the 1970s, standards began to develop that required zoos to start following certain guidelines for animal health and housing. The public watched diligently to assure that all creatures were treated ethically and respectfully, and barred cages started to become a thing of the past. The result was a safer, more conservation-minded zoo, whose goal was to increase natural awareness.

Now, in the early 21st century, the Oklahoma City Zoo is recognized for its high standards of care and conservation. Exhibits are naturalistic, portraying the actual habitat of each animal. Every inhabitant, from elephant to insect, benefits from a professional staff that is continuously researching new methods for preserving the earth's species. The zoo also makes great effort to adhere to its mission of educating visitors about the value and importance of biodiversity and living in harmony with nature.

From the early 1900s and on, the Wheeler Park Zoo and Lincoln Park Zoo housed many colorful and interesting creatures. Some were favorites, some were famous, and some were forgotten except to an older generation, but each had a quality that originally made them interesting, newsworthy, and, ultimately, worth photographing and recording for future generations. These animals and events are what have shaped the history of the Oklahoma City Zoo.

One

WHEELER PARK ZOO
1902–1909

When James B. Wheeler donated land from his neighborhood development for a park in 1902, he intended to attract families to his property. City leaders envisioned its primary purpose as a general recreation area but not specifically as a zoo. Oklahoma City believed itself to be in a race to establish itself as a "splendid city of the Midwest." Wheeler Park featured beautiful gardens and tree-lined paths, a skating rink, a magic-mirror parlor, and a miniature railroad. After a local man donated the first deer to the park, other animals followed. By late 1903, Wheeler Park had such a large menagerie of animals that on August 19, the *Daily Oklahoman* referred to the collection as "the zoo" for the first time in print.

Donations to the zoo came in the form of pets and wild-caught animals, ranging from wolves to golden eagles. Pres. Theodore Roosevelt had proclaimed special interest in coyotes, so interested out-of-state visitors flocked to see this never-before-seen creature on exhibit. By 1907, the growing list of animals included bears, pheasant, rabbits, ringtails, prairie dogs, fox, mountain lions, lynx, squirrels, bobcats, owls, opossum, raccoons, and a badger.

People visited this emerging zoo out of curiosity and for the purpose of entertainment. Visitors described the animals' antics in vaudevillian terms: as performances, stunts, and acts. A statement in the *Daily Oklahoman* summed up the 1900s attitude toward zoos: "Take the children—it's as good as a circus."

James B. Wheeler was a banker, civic leader, and land developer for the growing Oklahoma City. He obtained land near the North Canadian River in 1891. In 1902, he donated 44 acres to the city as a park. His motive was to attract homeowners to his nearby Wheeler Housing Addition. Another statement to his importance was that he had the first listed telephone number in Oklahoma City: No. 1. (Oklahoma Historical Society.)

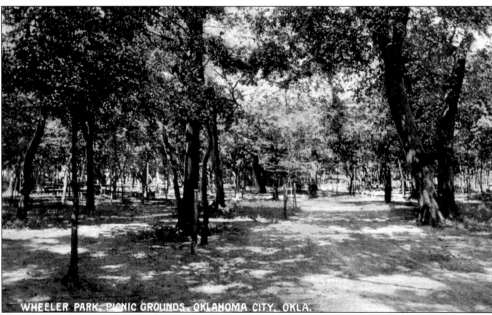

Wheeler Park, with its hundreds of cottonwood trees, served as a retreat for middle-class families seeking to reconnect with the great outdoors. Pres. Theodore Roosevelt, "Father of the National Park System," had sparked a back-to-nature movement. Oklahoma City visionaries were pleased that the newly donated land fit in with the larger parks movement sweeping across America. (Ernie Wilson Collection.)

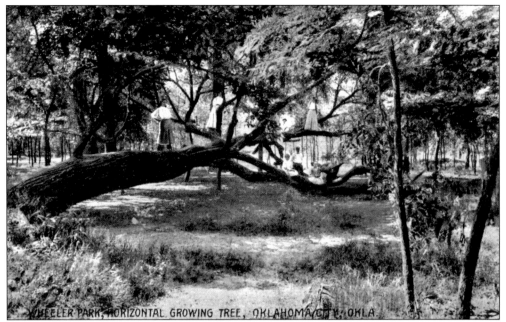

The Horizontal Growing Tree was a Wheeler Park landmark. Although visitors enjoyed climbing this particular tree, the rest of the park was considered too wild and overgrown by city planners. Many of the trees were cleared and replaced with manicured lawns, flower beds, and walking trails. James B. Wheeler had stipulated that the park receive a minimum of $2,000 in yearly improvements, and early on, much of that money was poured into landscaping. Wheeler's other requirements were that the park would forever bear his name, and, since he was a staunch supporter of Prohibition, no alcohol ever be served on the property. (Above, Pearl Pearson Collection; below, John Dunning Collection.)

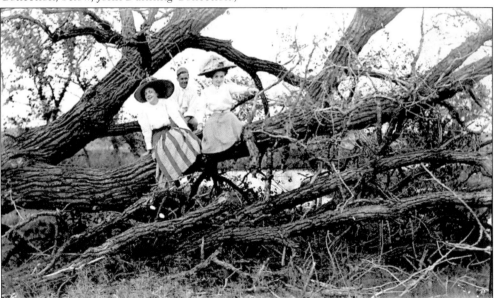

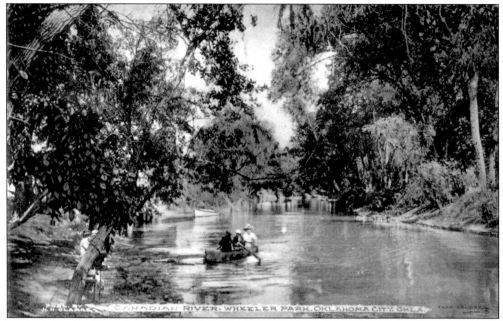

Visitors to Wheeler Park chose from a variety of amusements. Rowboats were popular for paddling up the North Canadian River as early as 1903. In 1905, a two-horsepower-engine boat was added, which seated eight people and an engineer. It became so popular, another engine boat was added the same summer. (Above, Ernie Wilson Collection; below, Pearl Pearson Collection.)

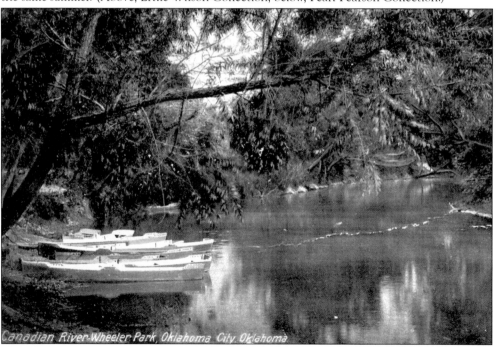

According to legend and secondary sources, the Wheeler Park animal collection began with the donation of a buck deer in 1902, when the park first opened. The buck was most likely a white-tailed deer, an uncommon sight because much of North America's wildlife had been hunted to near extinction. Its rarity drew attention, so park overseers added more deer, expanding the herd to nearly 20. (Above, Oklahoma Historical Society; below, John Dunning Collection.)

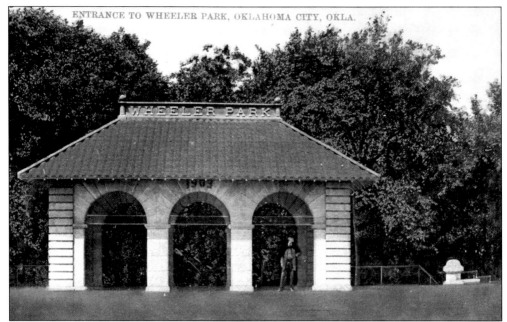

By 1903, the park had established itself as an area for tourism and community interest. The grand entry to Wheeler Park led to a 20-foot set of stone steps that descended down into the park. This structure, with its three arches and red roof, was built by the city in preparation for the formal dedication ceremony of Wheeler Park and its newly developed zoo on Labor Day, September 7, 1903. The celebration included a parade of 2,000 union men, floats, bands, a baseball game, and bicycle races. Electric streetlights, streetcar service, and train lines were extended to the park to accommodate the expected crowd. City leaders hoped that these capital improvements at Wheeler Park would help make Oklahoma City a contender in the race to be the "most attractive city in the southwest." (Above, Pearl Pearson Collection; below, John Dunning Collection.)

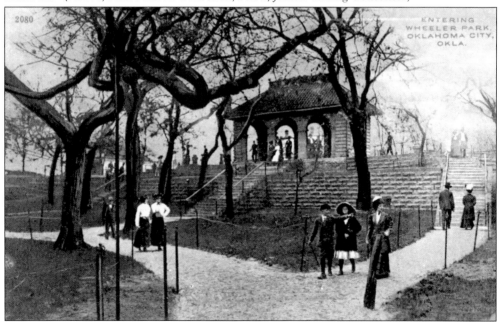

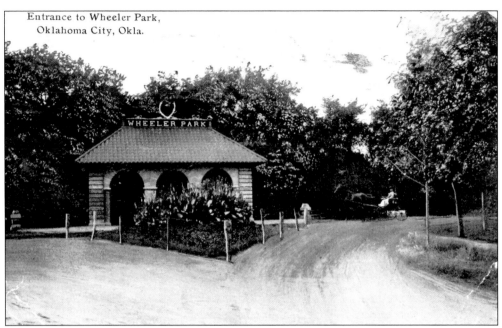

Entrance to Wheeler Park,
Oklahoma City, Okla.

Horses played a big role in Wheeler Park's first decade, not as zoo attractions, but as recreational animals. Taking horse-drawn wagon rides through the park was a regular family tradition. During the Labor Day 1903 celebration, tandem carts were brought in as a special feature. These small, single-person carts were driven, or possibly raced, a quarter mile with two horses hitched together in front. In either case, horses were a common sight in Wheeler Park until they were replaced by the automobile. Then horses were exhibited in the zoo for the enjoyment of city dwellers. (Above, Oklahoma City Zoo; below, Oklahoma Historical Society.)

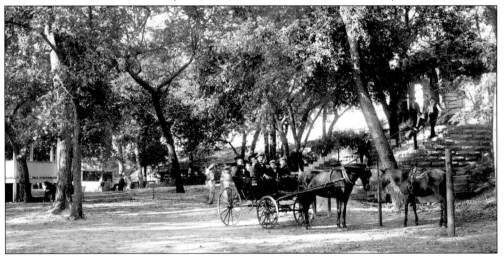

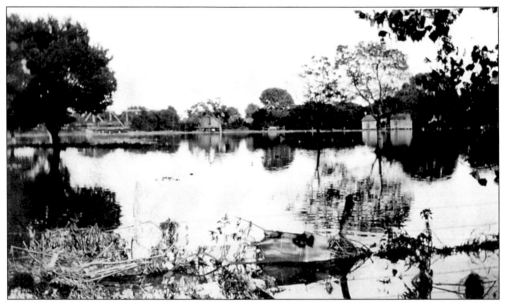

Because of Wheeler Park's location next to the North Canadian River, flooding was a problem each spring. Embankments were built, and the zoo animals were relocated several hundred feet northwest in 1905 to distance them from the river. However, the heavy rains continued to cause problems. Boxes were put into the animals' cages for them to crawl upon to get above the water. (Oklahoma City Zoo.)

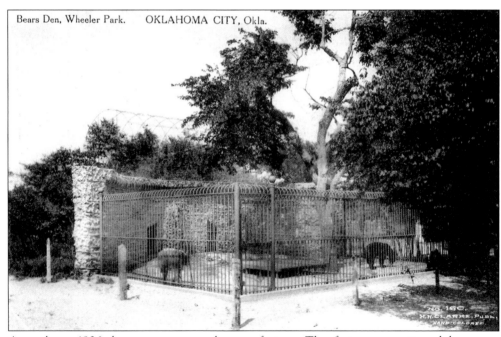

As early as 1906, bears were a popular zoo feature. The first one mentioned by name, Mr. Cinnamon Bear, arrived at Wheeler Park in 1906, followed by a pair of black bear cubs a year later. They were such popular animals that the zoo quickly added another cinnamon bear and two more black bears, Bryan and Roosevelt, to the collection. (Ernie Wilson Collection.)

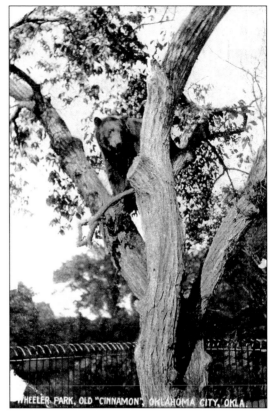

Wheeler Park's bears attracted huge crowds of 3,000 to 5,000 visitors on the weekends. To capitalize upon this, park commissioner Will H. Clark arranged to have Sunday performances by Old Bruin, the largest cinnamon bear. Clark lured him to climb a large tree in his enclosure by suspending a tempting slice of sugared bread from the highest branch. Penny postcards featuring Old Bruin's tree climbing and other Wheeler Park scenes were sold on the opening day of his act. (Right, Pearl Pearson Collection; below, Ernie Wilson Collection.)

WHEELER PARK, OLD "CINNAMON", OKLAHOMA CITY, OKLA.

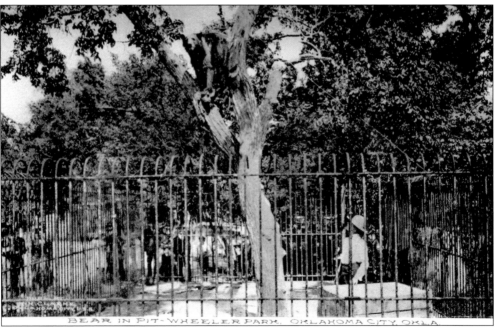

BEAR IN PIT-WHEELER PARK, OKLAHOMA CITY, OKLA

In 1907, Wheeler Park erected a large flight cage near the bear exhibit. The cage, 80 feet long and 21 feet high, was first built to accommodate five golden eagles. It is believed this cage was later transported to the site of the present-day zoo and is still being used to exhibit birds today. (John Dunning Collection.)

Jack and Bill, two bears weighing over 1,000 pounds apiece, were known as the zoo's biggest moochers, begging visitors for peanuts and popcorn. Whenever the park flooded, which often left it standing in 10 feet of water, Bill and Jack showed themselves to be agile swimmers. They ignored the scaffolding placed in their cage to raise them above flood level and instead spent their time swimming. (Oklahoma City Zoo.)

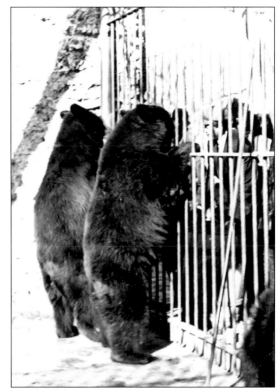

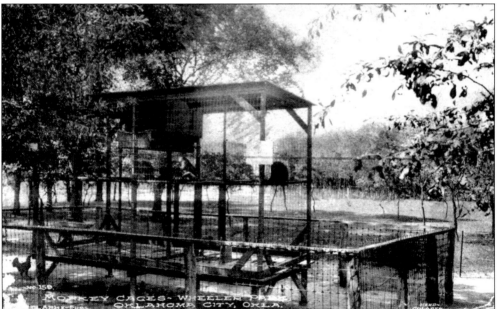

Probably the most colorful zoo inhabitants were the Saloon Monkeys. The owner of Two-Johns Saloon on Broadway donated his two monkeys after being forced to close his liquor emporium. This was due to the Prohibition law that came with statehood in 1907. The simian long-tails, Ben and Ted, were so adapted to saloon life that both were complete alcoholics and had to be weaned from liquor. (John Dunning Collection.)

The cool waters of the North Canadian River attracted a number of waders in the summer. As part of the 1907 Wheeler Park improvement plan, a number of water features were incorporated into the park's design. Wading and swimming pools were added for the visitors. Other ponds were created for exhibiting waterfowl, alligators, and the zoo's first exotic water animals, sea lions. (John Dunning Collection.)

This unknown female dangles above the North Canadian River. Nature photography made its debut to the average person in 1901, about the same time as the back-to-nature movement. The beauty of the river winding alongside Wheeler Park made it a popular backdrop for photographers. (Oklahoma Historical Society.)

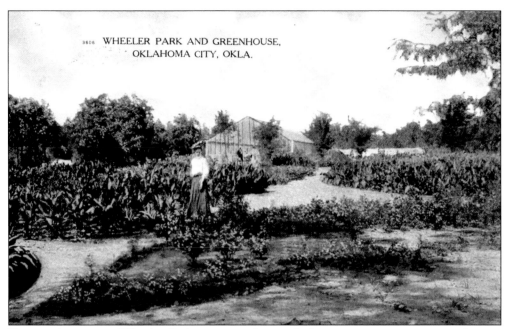

WHEELER PARK AND GREENHOUSE,
OKLAHOMA CITY, OKLA.

From its beginning, Wheeler Park maintained several plant conservatories, or greenhouses, which were open to the public. During winter, extra money was raised for maintaining the glass buildings by culling mistletoe from Wheeler Park's many trees to sell to the public. The first written record of an animal escape at Wheeler Park Zoo occurred in 1908, when an armadillo managed to get out of its winter quarters in the park's greenhouse. A crowd of citizens and hound dogs were called out to help in the lively chase, and shortly thereafter, the armadillo was recaptured, unharmed. (John Dunning Collection.)

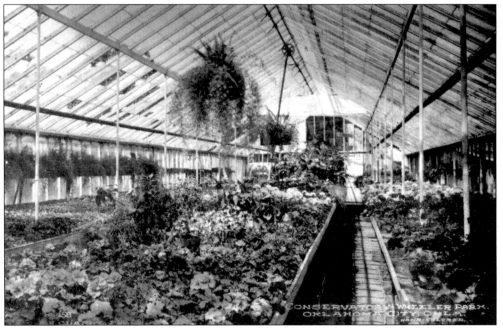

Two sea lions were purchased in 1908 using the proceeds from the Wheeler Park penny postcards. These frolicking creatures lived in a concrete pit called "the pond" and often drew more than 3,000 visitors daily. One incident, now considered unacceptable by modern professional practices, occurred when a young man kept throwing pebbles at the sea lions. A zoo official "seized him

by the nape of the neck and seat of his trousers and tossed him over the fence into the pool." The fellow moved quickly to get out of the pond, much to the amusement of watchers. A sign was added to the exhibit that read, "Do not throw any thing in this pond. $500 fine." (John Dunning Collection.)

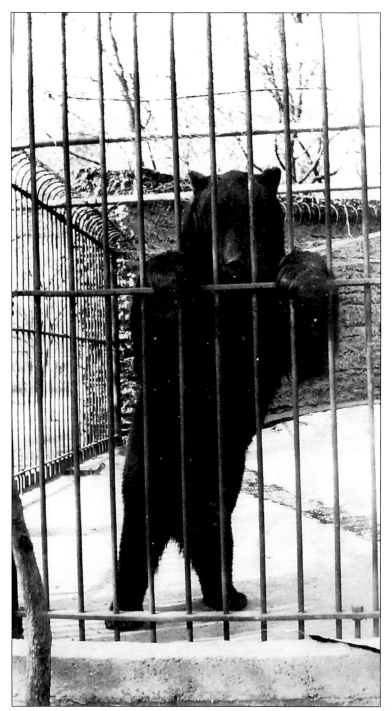

In 1909, a second animal escape occurred when four black bears broke out of their cage. Zookeepers and park superintendent C. E. Frank waited while they ran around the park, curiously climbing trees and beating through the brush. When the bears grew tired of exploring, keepers simply waved a slice of homemade bread at each cub, and "it was a case of who could get back to the cage the quickest." (Oklahoma City Zoo.)

Two

WHEELER PARK ZOO
1910–1919

From 1910 to 1919, officials at Wheeler Park Zoo decided to procure a variety of exotic animals—a costly endeavor, especially since food had become expensive and scarce during World War I. Even the zoo was not immune to "Hooverizing," the meatless and wheatless food-rationing requirements mandated by U.S. food administrator Herbert Hoover. Nevertheless, the collection of animals continued to grow. Zoo superintendent Joe H. Patterson said, "Despite war times, the stork continues his operations at Wheeler Park," and war-weary citizens flocked to the zoo for some much-needed entertainment.

Many visitor amenities were added, including a 100-foot wading pool, a bandstand, a refreshment stand, and many gardens and pathways. Improvements were made to the picnic area and the playground, which had swings and merry-go-rounds. Attendance during this decade was impressive, with thousands gathering to spend time outdoors with nature. Large numbers arrived in their automobiles to cruise along the paved roads. "Kodakers" brought their cameras, and many romances were kindled between uniformed servicemen and girls walking along a specially designed lovers' lane.

Citizens pressured the city to maintain and improve the zoo since it was the only zoological garden in the territory. New species of animals added to the zoo collection included an Alaskan wolf, elk, a groundhog, swans, golden pheasant, lemurs, macaws, billy goats, a mountain goat, Mexican hogs, hyenas, Egyptian geese, barn owls, a lion, rhesus monkeys, ferrets, cockatoos, and Mandarin ducks. The deer continued to thrive, and soon officials were faced with the problem of how to maintain such a large herd. Because of low funding, staff began to exchange animals with other zoos. The Parks Department also began growing its own alfalfa, oats, and corn to help feed the animals.

Several key animals, such as Ida the ostrich and Colonel Cody the bison, were given names and personalities during this decade. These animals frequently appeared in newspaper stories about the zoo, and certain "characters" became household names to Oklahomans.

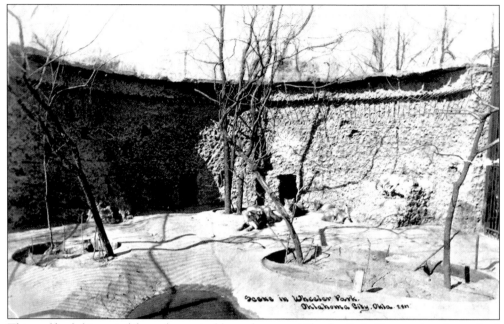

This wolf exhibit varied from the typical barred cage at Wheeler Park. One canine that gained notoriety during this decade was a gray wolf named Homer. He had an affinity for hens. His owner, a chicken farmer, decided that a wolf in the henhouse cost too much money, so in 1911, he donated Homer to Wheeler Park, and visitors flocked to see him. (Pearl Pearson Collection.)

A still-remaining zoo tradition began in 1911 when Wheeler Park allowed its first peacock to roam about freely. Gen. Roy Hoffman donated a male peacock to the zoo when he left for France. Hoffman was the famous Oklahoma commander of the African American 93rd Division, among the first to fight overseas during the war. The peacock was named Colonel Hoffman in his honor. (Oklahoma Historical Society.)

Band Stand—Wheeler Park

Because of Wheeler Park's large attendance and popularity, city planners continued to add visitor amenities. A bandstand provided a place for musical concerts. Gravel walkways crisscrossed the park, and in 1911, a lovers' lane was designed, complete with vines trained to cross above the trail. (Oklahoma City Zoo.)

Each spring, new gardens were added, and park attendants boasted of having 25 bulb beds and over 100,000 plants growing in the park. Every November, Wheeler Park hosted a chrysanthemum show. The show's popularity required that more greenhouses be added each year to maintain traffic flow. The greenhouses, called hot houses, were low structures, surrounded with sod mounds in the winter to protect the plants from freezing. (Ernie Wilson Collection.)

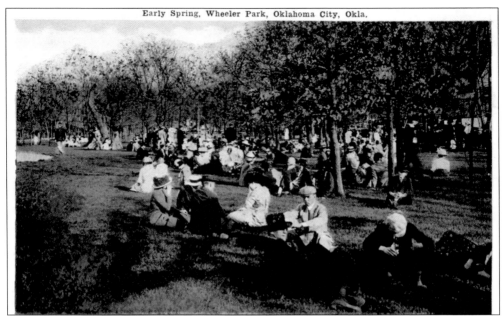

On March 19th, the first nice weekend of spring in 1911, between 5,000 and 8,000 visitors came to spend the day at Wheeler Park. The Oklahoma City Parks Department believed that the large number of picnickers, as depicted in this postcard, was a tribute to the nice grounds that had been maintained at Wheeler Park. (John Dunning Collection.)

The zoo's first snakes were originally part of a vaudeville show at the elegant Overholser Theater downtown. In May 1911, the performer Princess Indita ended her thrilling snake act to marry the treasurer from the Selis-Floto Circus. Before leaving for her new home in Denver, she donated her entire collection of exotic snakes to the zoo. (Oklahoma Historical Society.)

In 1911, a number of alligators and crocodiles lived in Wheeler Park's water exhibits. One alligator managed to escape into the Canadian River during flooding. A man in Choctaw, Oklahoma, found and kept the alligator in a bathtub, fattening him up to "sell to market." Wheeler Park officials identified the animal as their escapee, and papers were issued to reclaim the alligator. (Oklahoma Historical Society.)

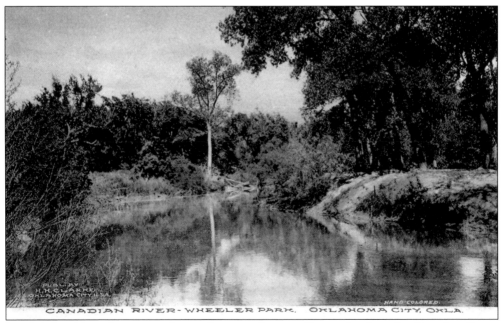

In 1918, local boys began circulating the story that an alligator lived in the Canadian River. Most adults ignored the reports until a watchman working along the canal, J. W. Linch, found the alligator swimming in the river. Wheeler Park later identified him to be the offspring of an alligator that had escaped from Wheeler Park during the 1916 flood. (Ernie Wilson Collection.)

Bobcats, which are native to Oklahoma, were among the earliest animals exhibited at Wheeler Park. The one balancing on the shoulder of this unknown man was apparently tame, but another one named Old Tom had a different reputation. He traveled to the zoo by express train from the Colorado Mountains in 1916. Upon his arrival, the feline's box bore a Handle with Care sign. Superintendent Joe. H. Patterson heeded the warnings of the railway men, who said he was the "wildest wildcat in captivity." Park visitors were cautioned, only somewhat jokingly, to be careful when coming too close to this cat's domain. (Left, Oklahoma Historical Society; below, John Dunning Collection.)

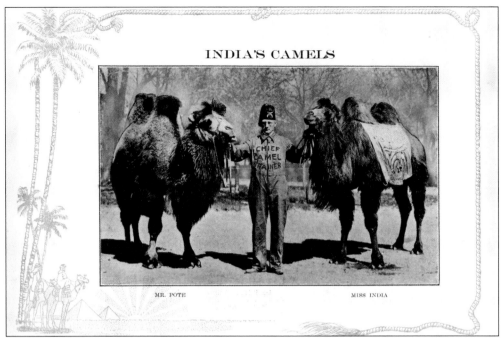

INDIA'S CAMELS

MR. POTE MISS INDIA

In 1916, the Shriner organization offered to purchase a female camel for Wheeler Park. In return for this, members could access her when they marched in parades. The Bactrian camel, named Miss India after the Shriners' India temple, arrived in October. A week later, she walked in her first parade wearing "Joseph's Coat of Many Colors," an ornate garment of bright colors, fringe, and satin. One year later, the Shriners purchased another camel, named Uncle George, to join Miss India. The two were "married" in a Shrine-style ceremony. Eventually George passed away and was replaced with Mr. Pote in 1917. Mr. Pote contracted tuberculosis, and Miss India was a "widow" for the second time. (Above, Oklahoma City Shriners; below, Oklahoma Historical Society.)

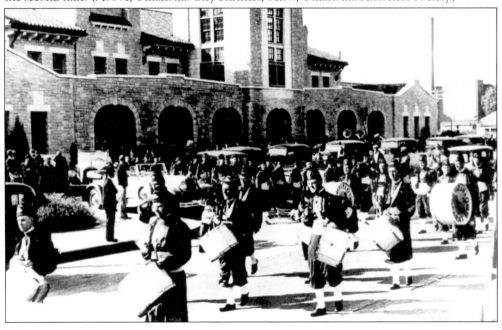

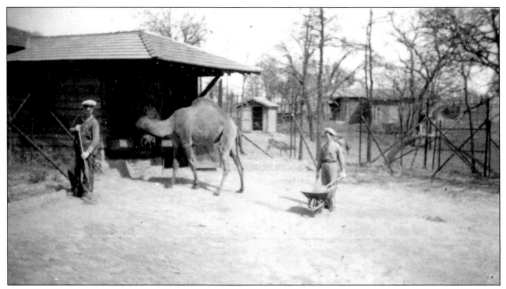

Housing camels did pose one unusual problem for the zoo—a high water bill. Despite the fact that camels were supposed to go days without water, according to park superintendent Joe H. Patterson, Miss India and her male cohort would line up at the watering trough eight or nine times a day for a good, long drink. Consequently, the park's water bill rose significantly. (Ernie Wilson Collection.)

In 1916, floodwater caused great damage to Wheeler Park and the railway property nearby. Even though a hole was cut in the levee to drain the water into the river, it only lowered five inches before stopping. No animals were lost, but Patterson began making plans to move them off their raised platforms and into the greenhouses. Over $5,000 in damages were sustained. (Oklahoma Historical Society.)

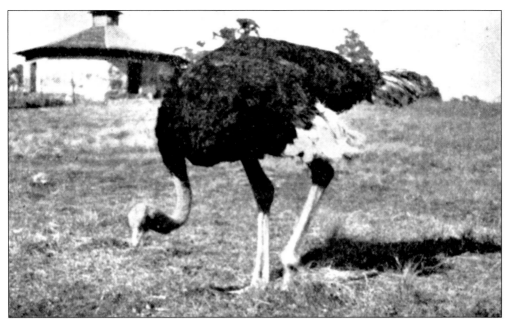

Ida the ostrich, the zoo's best-known animal in the early part of the century, arrived in 1916. By 1922, she had been featured in more newspaper articles than any zoo occupant. Her "sorrows and sufferings" were so public that she became an icon. Ida survived, despite relocation, widowhood, and disaster. In a way, she represented the average person who endured triumph and hardship during a difficult time in America's history. (Oklahoma City Zoo.)

Ida survived several mates. The first, Doc, ran into a fence and broke his neck in 1919. The second, Rudy, died within a year. Because of financial trouble, the zoo did not purchase Harold until 1926. Questions arose as to Harold's gender when he laid an egg. A monkey supposedly escaped and placed the egg under Harold. The scandal ended when Harold was proven to be male after all. (John Dunning Collection.)

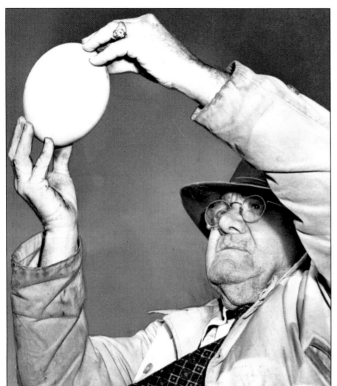

In 1917, Ida laid her first egg. Ostrich chicks were rare in early zoos, so employees anxiously watched the incubator. By the end of the year, Ida laid 38 nonproducing eggs, a trend she repeated for three more decades. Her eggs served other purposes in that they were sold to chefs, awarded grand prize in Easter egg hunts, and served at the first employee Ostrich Egg Breakfast on March 20, 1928. (Copyright 1947, Oklahoma Publishing Company.)

Ida survived the great 1923 flood by fleeing to an island of land above flood level. Bessie and Clara Loose, two girls stranded in a neighboring house, rowed over each day to feed her. Tragically, Clara and her mother were swept away in the waters one night and drowned while Bessie watched. Following the horror, Bessie formed a special friendship with Ida and often came to visit her. (Ernie Wilson Collection.)

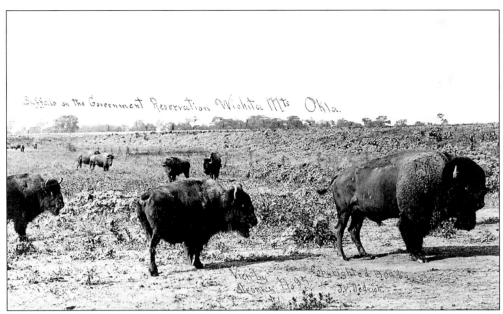

In the mid-1800s, the wild bison population went from the largest herd on earth to fewer than 300. In 1907, 15 bison were brought by railroad from New York's Bronx Zoo to the Wichita Bison Reserve outside Lawton, Oklahoma. That was enough to start a herd, which still exists today. In 1917, Wheeler Park convinced the government to sell a male, "Buffalo" Colonel Cody, to the zoo for a mere $85. Colonel Cody daily groomed himself and rolled in his homemade, six-by-ten-foot sandpit. Colonel Cody was named the finest bison specimen in any American zoo. Eventually he sired many calves, which contributed greatly to the bison population. (Above, Pearl Pearson Collection; below, Ernie Wilson Collection.)

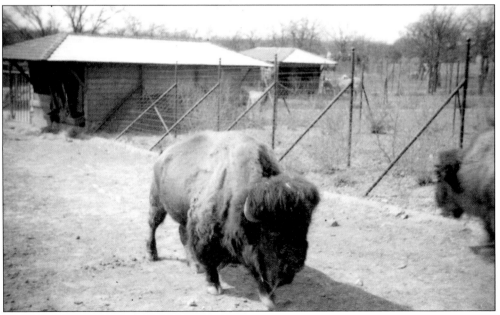

Sir Richard, a pelican that lived at Wheeler Lake, amused sightseers with his ability to always catch the fish thrown into the air by keepers. Only once did Sir Richard wander from his home. During one of the many floods, he hitched a ride on a passing log for a tour of the North Canadian River, near the state capital. Twenty-four hours later, zoo staff heard of his whereabouts and rowed over to get him. (John Dunning Collection.)

General Joffre, the zoo's first lion, preferred horse meat to beef. In 1918, feeding horse meat to animals became controversial. Zoo officials argued that carnivores liked it and it cost the city less money during the war. General Joffre won the argument when he ignored the beef wagon but reared up on his legs and growled loudly in anticipation when a horse meat wagon rounded the corner. (Oklahoma City Zoo.)

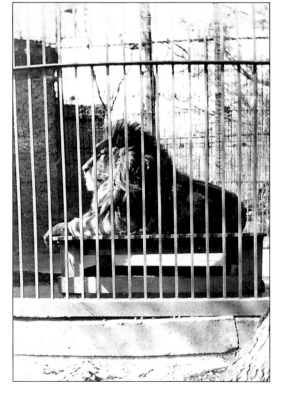

Three

WHEELER PARK ZOO MOVES TO LINCOLN PARK
1920–1929

In the early 1920s, Wheeler Park continued to be plagued with numerous floods. After a 1923 rainstorm, the zoo lay submerged under 10 feet of water. All the surviving animals were temporarily transferred to the barns at the state fairgrounds located at Northwest Tenth Street and Eastern Avenue.

In September 1923, park superintendent Joe H. Patterson purchased land for a new zoo site at the current location of Northeast Fiftieth Street and Eastern Avenue. The move was controversial because the land was underdeveloped, and no public transportation traveled to Lincoln Park. Businessmen rallied to improve the area and convinced the Oklahoma Railway Company to add service to the park.

Building the new zoo took a year, so gates stayed closed to the public until June 1924. Animals continued to be added, however, including a large variety of birds, a baboon, spider monkeys, elk, leopards, a porcupine, a sloth, a llama, a wallaby, and water buffalo.

One particular deer, who had fled during the June flood, wandered back to his Wheeler Park home seven months later. He found it deserted. Luckily zookeepers found him in his old barn and moved him to his new home in Lincoln Park.

By the mid-1920s, Patterson faced more budget cuts and a shortage of cages. He secured private donors who committed to purchasing additional animals, but only if the Parks Department would continue to fund the new zoo. It worked. Money was left in the budget, and a 4,000-square-foot building was built to house small birds and mammals. This structure, made of pink granite, still stands today as the Herpetarium.

Wheeler Park endured disaster and reorganization in the 1920s, but, ultimately, the zoo was preparing to become a permanent fixture in the community after relocating to Lincoln Park. When it did open, weekend crowds often numbered over 25,000.

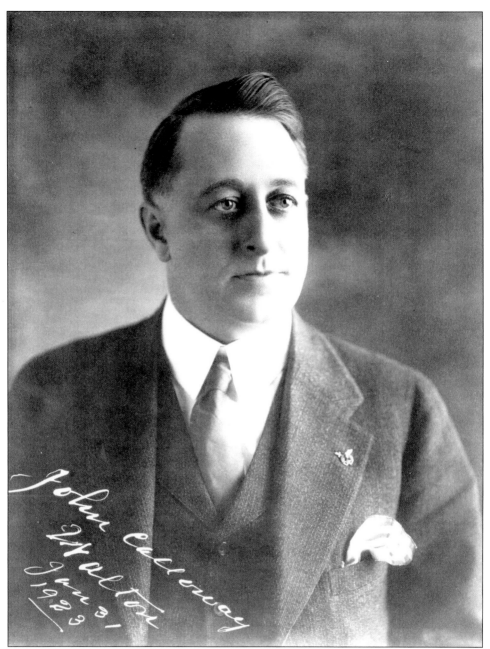

In 1922, Barbecue Bear was purchased by children trying to rescue him from being barbecued at the inaugural barbecue party of Governor-elect John C. Walton. Walton invited all Oklahomans to the party, and over 80,000 people showed up! In fact, they came weeks early, from all over the state, posing housing and feeding problems. The city could not afford enough meat to feed so many people. The chairman of the inaugural committee, Dan Lackey, was forced to devise an award for the first county to send a carload of meat to Oklahoma City. Although the honor went to farmers in Bryan County, and they were invited to lead the inaugural parade, other counties got into the spirit of the contest and began sending truckloads of food. (Oklahoma Historical Society.)

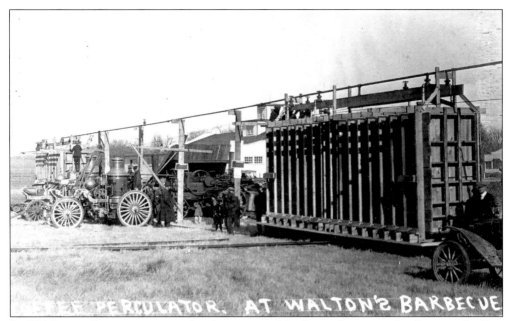

In Oklahoma City, preparations for the inaugural barbecue began at the fairgrounds. City workers constructed the world's four largest coffee urns. They measured 5 by 9 by 24 feet and were able to hold 8,500 gallons each. The wooden urns, lined with tin, were steam heated by a large engine. Food started arriving in massive amounts: livestock, rabbits, geese, buffalo, turkey, deer, squirrels, possums, and more. Farmers from Sayre, Oklahoma, brought a live bear. The bear was exhibited in the lobby of the Lawrence Hotel until butchering day. He escaped several times and scared and injured hotel staff. Ironically, the man who recaptured him was the grand chef of the barbecue. The fiasco attracted a newspaper correspondent from Paris, who came to America to cover the story. (Oklahoma Historical Society.)

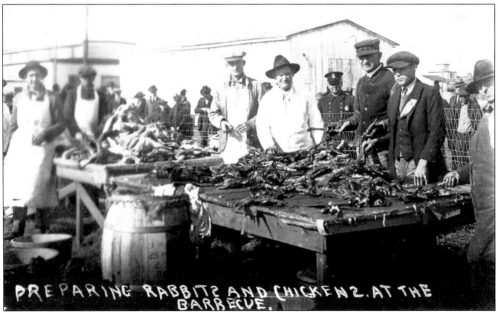

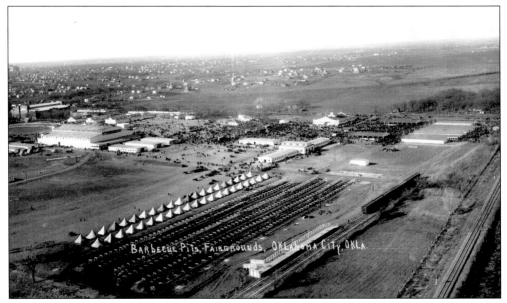

At the fairgrounds, workers dug trenches, which spanned over a mile, for barbecue pits. Truckloads of firewood filled in the trenches, which were then covered in wire netting to place the meat upon. Fifteen sheds and various horse stables were converted into food-serving areas. Hundreds of men were employed as builders, chefs, and servers, and the National Guard was engaged to control the crowds. (Oklahoma Historical Society.)

Meanwhile, children felt sorry for the bear about to be barbecued. They started raising money to buy him from the governor-elect. With days to spare, the children raised 11,966 pennies! John C. Walton had little choice but to accept the money and release the bear to the zoo. By then, the bear had earned the name Barbecue Bear. For the next 10 years, he was considered the zoo's most famous bear. (Oklahoma City Zoo.)

40

During heavy rains, the levees built near Wheeler Park proved to be insufficient. In April 1922, water began seeping into the zoo. A force of men built scaffolding for the large animals, relocated the smaller ones, and transported 100,000 plants. Then, in May 1923, a larger storm left Wheeler Park 12 feet underwater and with $10,000 in damages. In an effort of mercy, many animals were released from their cages to fend for themselves just moments before the water poured over the Frisco railroad tracks into the zoo. One month later, another flood left Wheeler Park eight feet underwater. At this point, Joe H. Patterson decided to relocate the zoo. Surviving animals were moved to the fairgrounds until a new site could be selected. October brought an even larger flood, assuring park officials that they had made the right decision to leave. (Oklahoma Historical Society.)

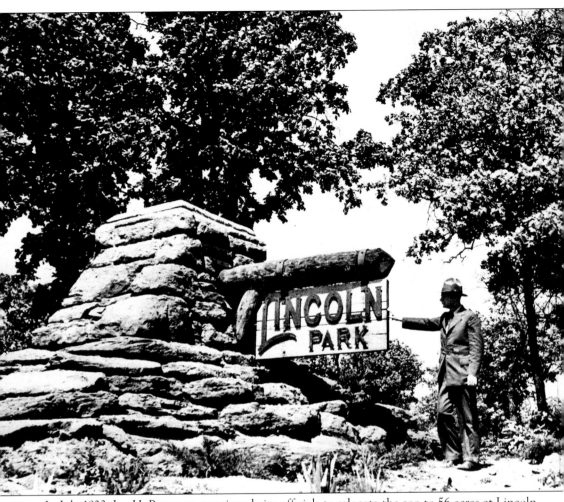

In July 1923, Joe H. Patterson convinced city officials to relocate the zoo to 56 acres at Lincoln Park. First, many preparations were needed: dirt paths replaced with asphalt, electric lighting installed, and animal enclosures built. Since the zoo did not open to the public for a year, newspapers informed the public about their favorite animals. Lincoln Park Zoo's official opening was on June 7, 1924. (Oklahoma City Zoo.)

Lincoln Park had been purchased by the Parks Department in the early 1920s. Its 540 acres were largely undeveloped, except for a playground, golf course, and the 75-acre Northeast Lake. The south side of the lake was dedicated to summer tourists. Tent-camping sites were available for rent, and dirt roads were popular with cruising motorists. (John Dunning Collection.)

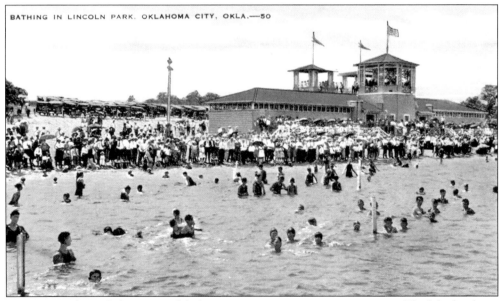

In 1922, Northeast Lake was modified to attract even more summer tourists. The lake level was lowered, and sand was added to turn it into a public swimming beach. This bathhouse was built on the west side, complete with showers, lockers, and restrooms. (Ernie Wilson Collection.)

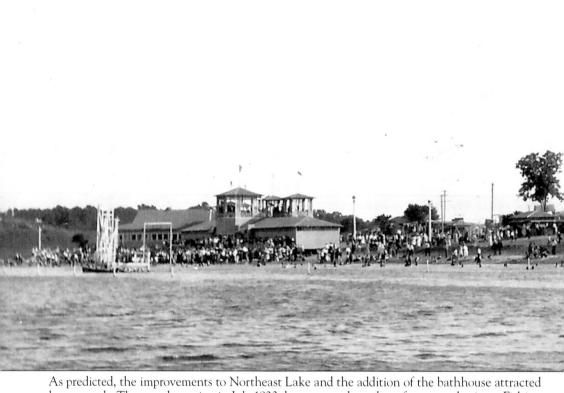

As predicted, the improvements to Northeast Lake and the addition of the bathhouse attracted large crowds. The grand opening in July 1923 drew a record number of water enthusiasts. Fishing

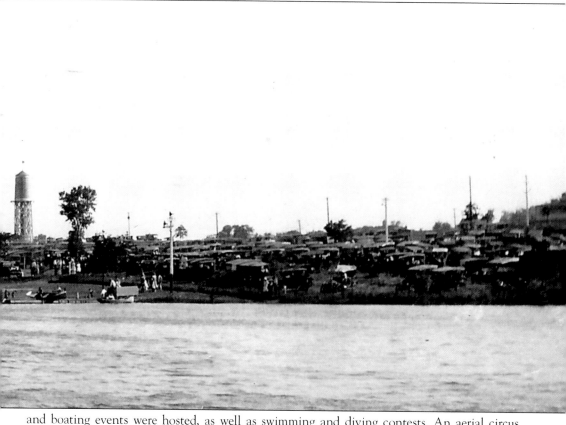

and boating events were hosted, as well as swimming and diving contests. An aerial circus performed above the lake during the festivities. (John Dunning Collection.)

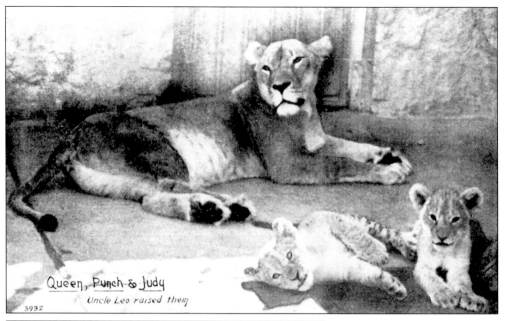

Queen, Punch & Judy
Uncle Leo raised them
3932

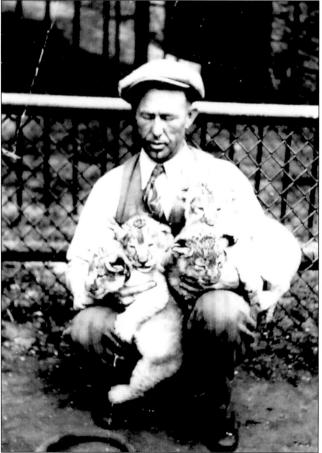

Beginning in 1925, Queenie began producing the first of 50 lion cubs. Her first surviving litter, three male cubs, were named Athos, Porthos, and D'Artagnan, after the characters from *The Three Musketeers*. Their successors were a quartet of lion cubs. While the public remarked how cute and cuddly they were, zookeepers had to vigilantly remind visitors that lions do not make tame pets. The four lions were then traded to make room for Queenie's next litter of five. The quintuplets were believed to be the first set of five lions ever to be born in captivity. The four males and one female were named after local politicians. (Above, John Dunning Collection; left, Oklahoma City Zoo.)

Four

LINCOLN PARK ZOO
1930–1939

In the early 1930s, zoo staff asked citizens which new animal they wanted. They responded, an elephant! When Luna arrived, hundreds of children escorted her through town during a welcoming parade. The event signaled a decade of change for Lincoln Park. Oklahomans, combating the Great Depression, were looking for inexpensive entertainment. Leo Blondin, zoo director and veteran circus performer, knew how to entertain. He trained many of the animals to perform tricks and involved the community in zoo functions.

When Blondin's salary was eliminated in 1931 because of the recession, so many complaints were filed that he was reestablished to his post. By the end of the decade, Blondin was nominated as Oklahoma City's Most Useful Citizen for bringing "more happiness to the people of the city, especially the children, than any other citizen."

Not only did Blondin begin the zoo's first veterinary clinic, he added many species to the collection, including iguanas, prairie chickens, cassowaries, coatimundi, a tiger, Gila monsters, a yak, a goshawk, and a black-tailed deer. As exotic animals were added, zoo officials became worried about the declining numbers of native species in the zoo and in the wild. Taxidermic specimens of animals were displayed in a Heads and Horns exhibit for scientific study.

Budgets continued to be cut, and acquiring new animals was accomplished by trading with other zoos. Crops were grown to reduce food costs, and a cow was milked daily to help feed the baby animals.

Finally a boost for the zoo came when Pres. Franklin Roosevelt established the Civilian Conservation Corps to revitalize community land improvements. The Civilian Conservation Corps established a work camp at Lincoln Park in 1933, and the men helped build gardens and a playground for Lincoln Park. The Works Progress Administration (WPA), a relief measure established to provide work for the unemployed, allotted $250,000 for improvements at Lincoln Park in 1935. The WPA built the zoo's amphitheater, bathhouse, and grotto exhibits, which still exist today in modified form. Despite hard economic times, the zoo managed to thrive because of community efforts and federal funding.

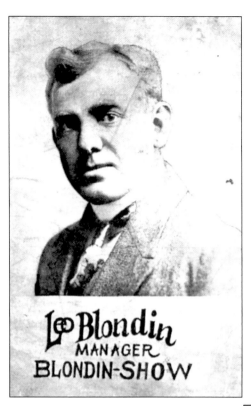

In August 1930, park superintendent Ernest B. Smith decided to turn the zoo's management over to a dedicated director. Leo Blondin, a former circus performer, was hired. Blondin was famous for holding the world's long-distance leap record for jumping over four elephants, six horses, and six camels! Following his circus years, he owned a traveling animal act, the Blondin Stock Show based out of Oklahoma City. (Oklahoma City Zoo.)

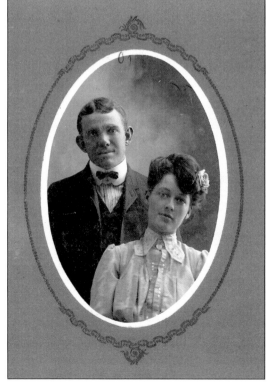

Leo Blondin was born in a circus tent as William Lee Balding but changed his name to Blondin when he went into show business. This stage name was selected because of Charles Blondin, a famous European daredevil. In 1902, Leo Blondin married Eleanor Taylor. This is their wedding portrait. Eleanor was both a performer and a joint manager of the Blondin Stock Show. (Oklahoma City Zoo.)

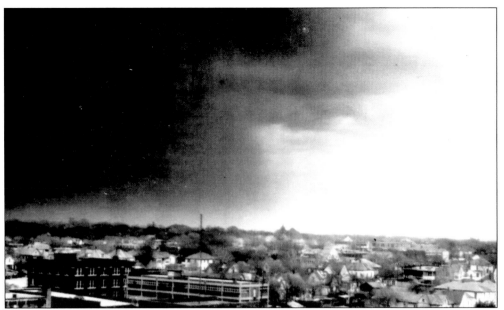

Following World War I, economic instability and drought hit the country. Dust storms resulted from overused land, turning the Great Plains into a desert called the Dust Bowl. For this reason, the 1930s decade became known as the Dirty Thirties. This picture, taken from the top of the Daily Oklahoman building, shows the dust sweeping across Oklahoma City. (Oklahoma Historical Society.)

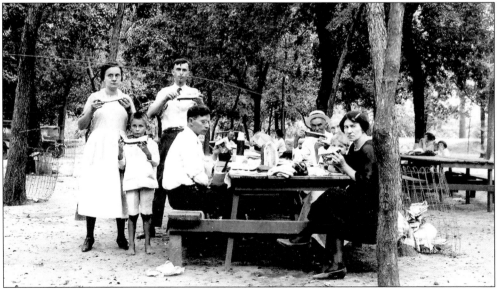

The fun circus atmosphere Blondin created at the zoo became an escape for citizens battling hard times. For no cost, families could play at the lake, have a picnic lunch, and visit the animals. Special concerts, clown acts, and animal performances drew additional visitors, and summer crowds often reached 25,000 to 35,000 people. (John Dunning Collection.)

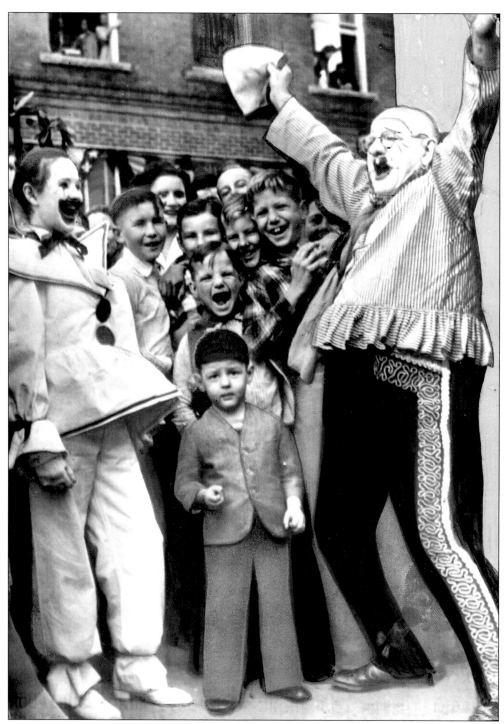

Leo Blondin, who had worked for the circus 23 years prior to his zoo position, frequently donned his old clown costume and wore it on grounds to the delight of zoo visitors. He welcomed school groups and mingled well with the public. On occasion, he held circus presentations, sharing the tricks he taught various zoo animals. (Copyright 1947, the Oklahoma Publishing Company.)

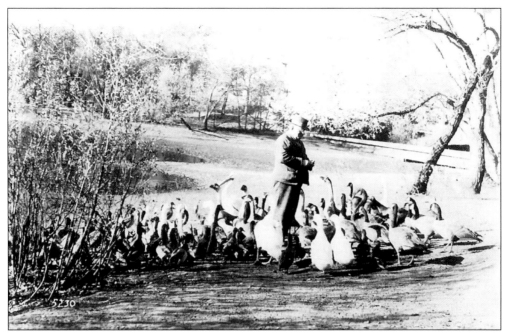

Blondin, who was like family to many people, became known as Uncle Leo. He invited children to be members of the Uncle Leo Club. He hand signed and mailed each member various postcards, such as this one of him feeding geese at Northeast Lake. (John Dunning Collection.)

Each Wednesday night, beginning in 1929, Blondin had a radio program for children on local station WKY. The show featured Blondin sharing fun and informative stories about zoo animals and about his former circus experiences. Members of the Uncle Leo Club were avid followers of the radio program, making it successful for 17 years. (Copyright 1936, WKY.)

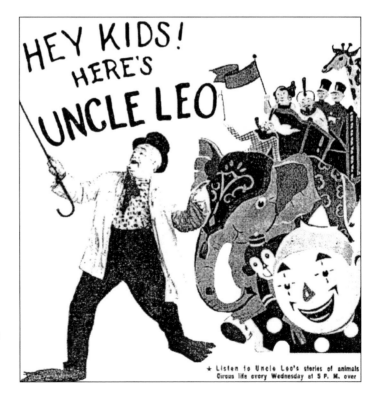

In the 1930s, Oklahomans wanted more exotic animals for Lincoln Park Zoo—especially an elephant. It was a difficult time, however, because the zoo faced famine. Feeding an elephant would present financial difficulties for a tight food budget with just $824 remaining. Nonetheless, an elephant from Kansas City was purchased at the price of $2,750. Citizens, especially children, pitched in to help buy Luna the elephant. (Oklahoma City Zoo.)

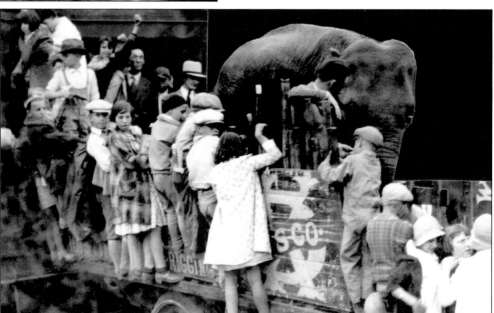

When Luna arrived on April 25, 1930, hundreds of children greeted her in a welcoming parade. They patted the six-foot elephant while escorting her through the city to the tune of "I Went to the Animal Fair." Every block became more crowded as the procession headed toward the zoo. Amazingly, Luna stayed calm during the chaos. The event made the *Daily Oklahoman*'s 1930 list of top state and national events. (Copyright 1930, the Oklahoma Publishing Company.)

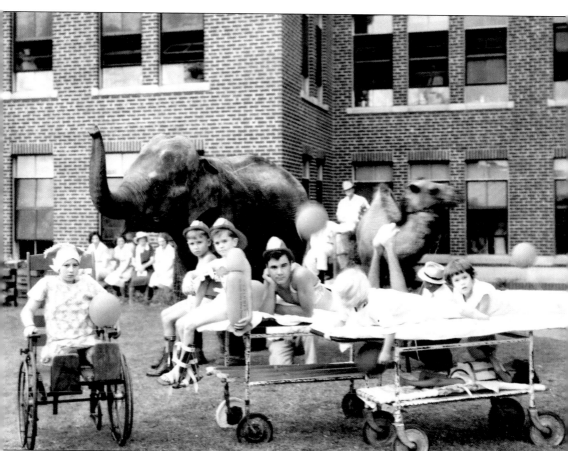

Luna, nicknamed the "flapper" elephant, became a traveling ambassador for the zoo. She frequently made visits to Crippled Children's Hospital. The patients, largely suffering from polio and rheumatic fever, were wheeled into the courtyard to spend time with the famous elephant. One of her ankles was chained to the ground so that she could not move about freely. (Copyright 1932, the Oklahoma Publishing Company.)

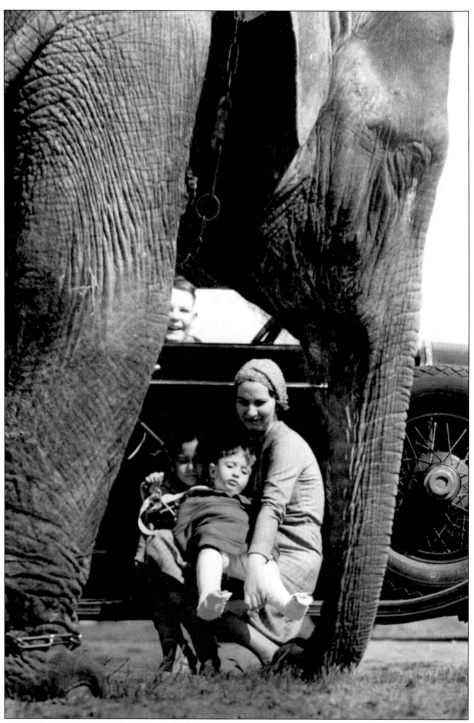

In this picture, patients from Crippled Children's Hospital made a special field trip to the zoo. Luna put on a show, and then her guardrails were let down so the young visitors could be driven by in automobiles for a close look. Nurse Grace Kirby holds these two children wearing leg casts in her lap. (Copyright 1932, the Oklahoma Publishing Company.)

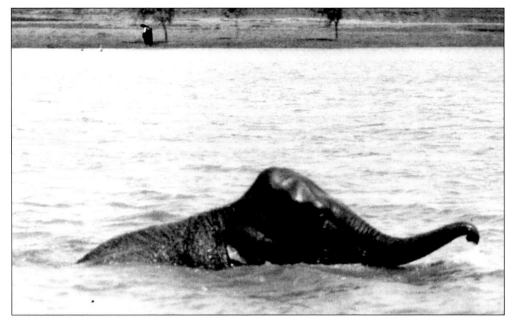

Luna put on quite a show whenever she took her bath in Northeast Lake. She would roll and dive, trumpeting so loudly that she could be heard throughout the park. Although this event drew many spectators, others expressed anger at being forced out of the water so Luna could bathe. At different times, the rule was changed so the public could freely swim in the water with Luna. (Copyright 1931, the Oklahoma Publishing Company.)

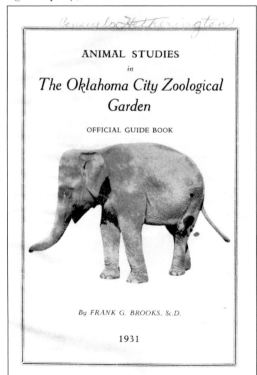

In 1931, the zoo's star elephant was featured on the cover of a booklet that was handed out free to visitors. The information inside included the scientific name and natural history of each animal species living in Lincoln Park. The 1930s also saw the addition of similar signage on the animals' cages. (John Dunning Collection.)

Crowds flocked to visit Luna at the zoo. Being the queen of Lincoln Park meant special treatment for the elephant. When Leo Blondin learned that she feared dogs, he banned them from the zoo. When the WPA crew built her this new grotto home, it came furnished with a special wooden bed so that she would not have to sleep on the concrete floor. In winter, she got a steam-heated structure. Her enclosure even had French doors, but she broke them down, and they had to be replaced with lumber planks. One year, Blondin had a special truck designed so that she could ride in the Christmas parade. (Above, Oklahoma City Zoo; below, John Dunning Collection.)

Luna became a popular performer for the zoo, especially with Blondin as zoo director. The two made appearances at various functions. In September 1931, Luna was a guest of Mayor C. J. Blinn's at the Oklahoma State Fair. In 1932, she helped the League of Young Democrats solicit votes. In this 1948 publicity photograph, she poses with bass fiddle player Roy Duncum to help advertise an upcoming Oklahoma State Symphony performance. (Copyright 1948, the Oklahoma Publishing Company.)

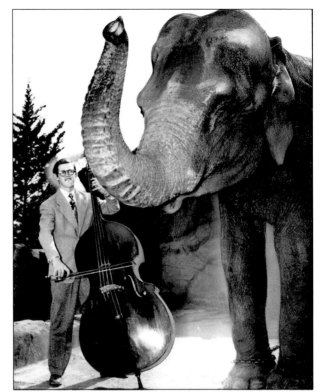

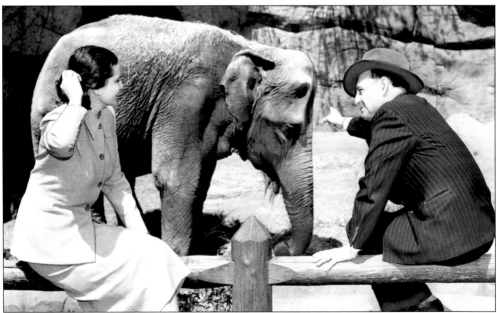

The Oklahoma State Symphony presented "The Carnival of the Animals" for children in fourth, fifth, and sixth grades. Conductor Victor Alessandro pointed out that although Luna could not play a musical instrument, she would be a great asset to the show. Luna was taken to the Municipal Auditorium (now the Civic Center) and did a repertoire of tricks before the concert. (Copyright 1948, the Oklahoma Publishing Company.)

Leo Blondin frequently took Luna for walks around the zoo or down to the lake for her bath. Blondin sent this postcard of their walk to Uncle Leo Club members. At one point, Luna escaped during one such walk, although Blondin was accused of setting the episode up to attract media attention. (John Dunning Collection.)

Luna began having foot problems, not uncommon to captive elephants in the 1940s. She had a regime of pedicures, but her feet continued to deteriorate over time. In 1948, zookeepers made these special shoes for her out of large bags. They put cracked ice and medicine inside to soothe her sore feet. Continued foot problems eventually led to her passing in 1949. (Copyright 1948, the Oklahoma Publishing Company.)

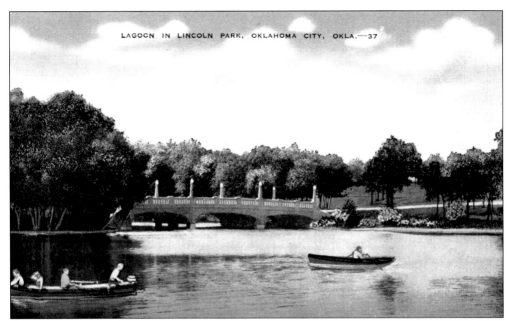

LAGOON IN LINCOLN PARK, OKLAHOMA CITY, OKLA.—37

Despite higher elevations, Lincoln Park Zoo occasionally suffered flooding from the nearby lake. During one flash flood, several animals drowned. A baby bison was born in the excitement, so he was named Lightening. In 1932, the Parks Department stocked Northeast Lake with 4,000 bass and instituted fishing regulations. Blondin, along with his zoo management duties, became game warden in charge of viewing all strings of fish caught in the lake. (Pearl Pearson Collection.)

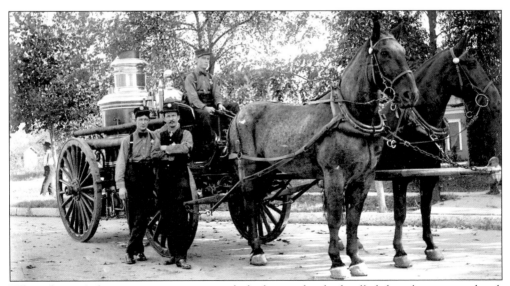

When the city's fire engines were motorized, the horses that had pulled them became outdated. Over time, firemen thought all the former fire-station horses had died. One of the horses, named King, had gotten lost in the shuffle because he went on inactive duty after his previous teammate had died during a fire. When he was discovered in 1932, King was sent to Lincoln Park for retirement. (Oklahoma Historical Society.)

The zoo's first Civilian Conservation Corps from Fort Sill established a work camp at Lincoln Park in October 1933. They cleared land, began work on a playground, and built footpaths. They also helped build a branch zoo at Wiley Post Park at Northwest Seventeenth Street and Robinson Avenue. The new zoo, consisting mainly of Lincoln Park's surplus animals, existed for several years. (Ernie Wilson Collection.)

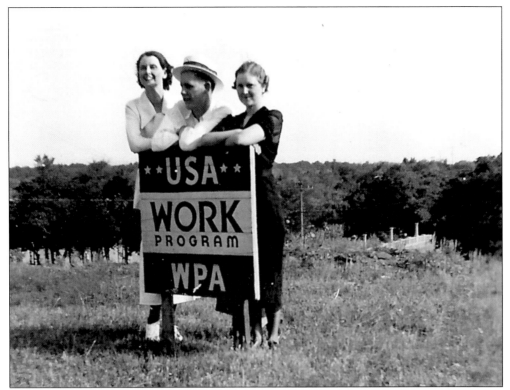

In 1935, the WPA, begun by Pres. Franklin Roosevelt, allotted $250,000 for improvements at Lincoln Park. Workers of the WPA built the zoo's amphitheater, bathhouse, grotto exhibits, the golf course next door, and a number of other structures, which still exist today in modified form. (John Dunning Collection.)

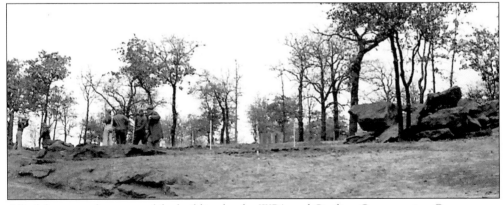

All of the natural stone used for building by the WPA and Civilian Conservation Corps camps was quarried from Lincoln Park property by workers with pickaxes. It is believed that the land sculpture of the present-day zoo is a result of these excavations. (John Dunning Collection.)

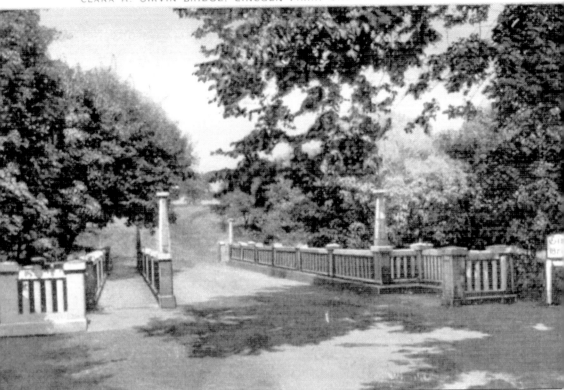

This bridge, located at the south entrance of Lincoln Park Zoo, was named after Clara Girvin in 1923 since she was the first woman to serve on the Oklahoma City Parks Board. The bridge can be seen in the WPA picture on the previous page, and it still exists today in the center of the zoo, next to the pachyderm building. (Ernie Wilson Collection.)

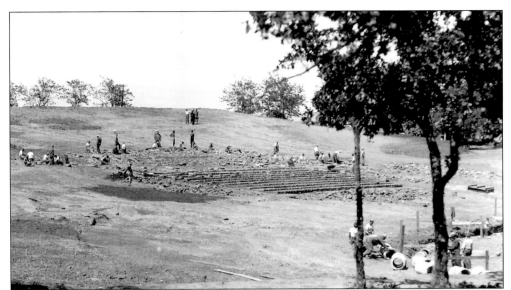

In 1935, WPA plans called for the building of a natural outdoor amphitheater to seat 1,000 people. Leo Blondin intended to use the stage for his animal shows. As early as 1936, the amphitheater hosted several circus acts and concerts and was the site of the annual Easter Sunrise Pageant. Bleacher seating was built from quarried stone. The open-air theater is still used as a concert venue, although most of the rock seating no longer exists. (Ernie Wilson Collection.)

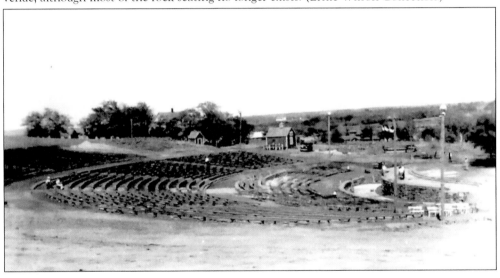

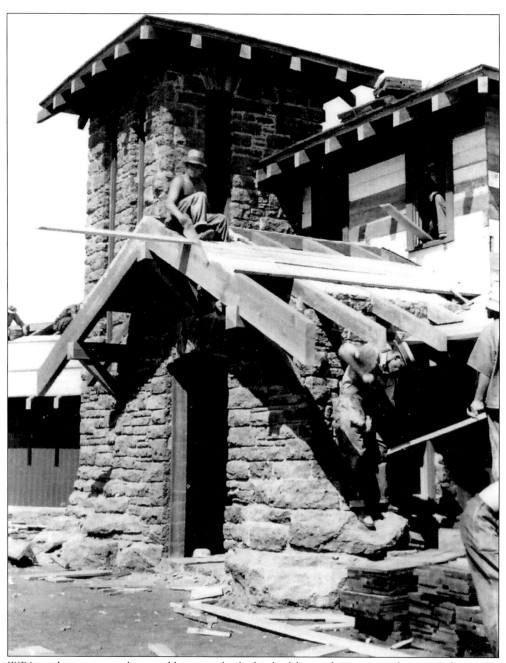

WPA workers, wearing hats and bow ties, built this bathhouse from quarried stone. It featured a central hub, with a girls' wing and a boys' wing extending from the sides. Bathers at Northeast Lake used the interior stalls for changing into their swimsuits. It is believed the original Lincoln Park bathhouse may have been lost in a fire. This structure, however, still exists on zoo grounds. (Ernie Wilson Collection.)

In 1907, a new style of zoo exhibit, developed in Germany by Carl Hagenbeck, offered visitors an uninterrupted view of zoo animals. The barless exhibit, called a grotto, was an island surrounded with a moat, which kept onlookers and animals separated by distance. As early as 1933, Leo Blondin wanted Lincoln Park to have these state-of-the-art grottoes, so when funding became available, it became a WPA project. The design was modified so that instead of allowing visitors to circle all the way around the exhibit, a long row of pits, surrounded by concrete on three sides, was built with a moat along the front for visitor viewing. (Ernie Wilson Collection.)

The WPA began work on nine cat grottoes in 1936, followed by bear and elephant grottoes in 1937. When finished, the interior buildings of the pits were covered with concrete to look like dens made of boulders. Although the pits are considered stark in contrast to today's natural-looking exhibits, they were a leading-edge design in the 1930s. Most of the grottoes still exist today along the edge of Northeast Lake. (John Dunning Collection.)

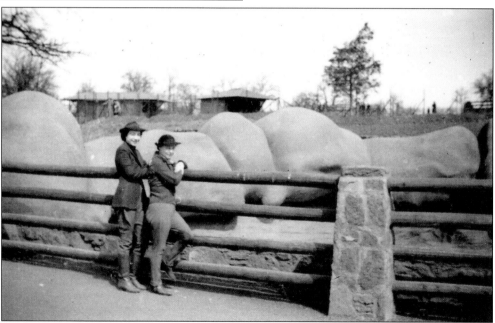

These women, wearing riding gear, look into one of the finished grotto exhibits. Lincoln Park originally allowed visitors to travel through the zoo by automobile, on foot, or even on horseback. (Ernie Wilson Collection.)

In 1935, Cimarron, a brown bear, had such tremendous odor that staff, visitors, and other animals fled from him. When the other bears rejected the smelly new roommate, the zoo decided to relocate him until the odor dissipated somewhat. The final solution: house him with the skunks. The skunks adjusted well, and after time, and several baths, Cimarron was promoted back to the bear den. (John Dunning Collection.)

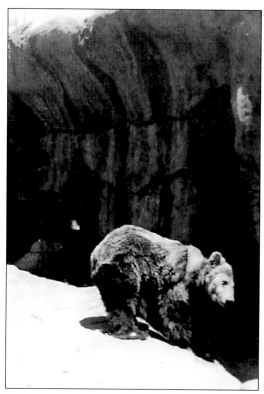

Jerky the monkey is the only Oklahoma City Zoo animal to testify in court. In 1934, a man sued Lincoln Park, charging that a monkey had bitten his daughter's finger through the cage. Leo Blondin brought in Jerky as exhibit A and a sample of wire cut from the actual cage. He demonstrated that the monkey could not reach through the wire fencing to get at a peanut. The verdict: not guilty. (Oklahoma City Zoo.)

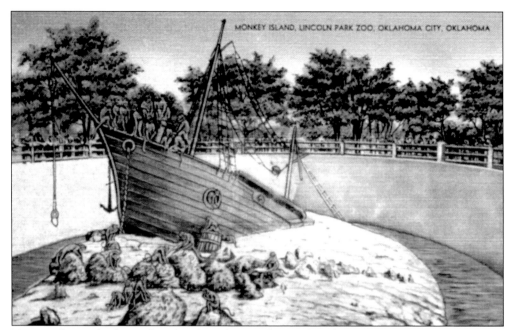

Not one, but multiple monkeys lived on the popular monkey ship at Lincoln Park. In 1935, the circular exhibit, called Monkey Island, was built just inside the north entrance by the WPA. Monkey ships had been popularized by other zoos. The original sunken pirate ship had an 80-foot-long boat with a 17-foot mast for its residents to climb on. The underground quarters were one of the few zoo exhibits to have a heating system. (Ernie Wilson Collection.)

Initially, the island featured 35 rhesus monkeys since they were considered the liveliest of the primates. Leo Blondin began bargaining to add more rhesus to the collection, and his first trade resulted in the popular duo of Joe and Clara, a team who had been in show business together. Next the zoo decided to exhibit multiple species of monkeys together. Five ringtail lemurs were added in 1936, but they were such bullies to the rhesus that Blondin banished them from the ship. One particular monkey, Old Jack, took command of the ship in 1937. Physically he was old, had no teeth, and could hardly see, but somehow he got in his bluff. The ship's other inhabitants followed his rule and only ate after he had gummed bananas to his fill. (Right, Ernie Wilson Collection; below, John Dunning Collection.)

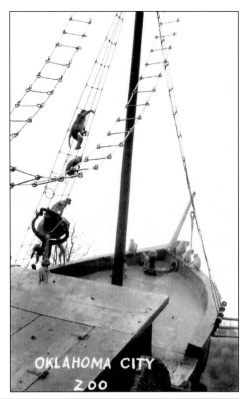

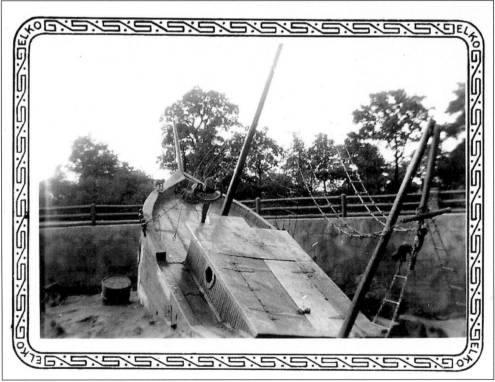

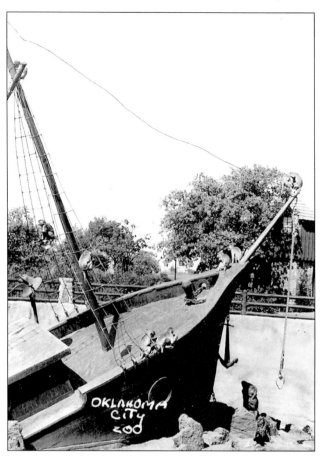

The monkey ship was located inside the zoo's entrance gates for over 60 years. It required constant repair work, and the housing situation posed many sanitary problems for the animals. In 1998, zoo officials decided to eliminate the outdated exhibit and focus their attention on developing the area as the Global Plaza entrance. Even so, many visitors fondly recall the monkey ship that had once been a prime attraction. (Ernie Wilson Collection.)

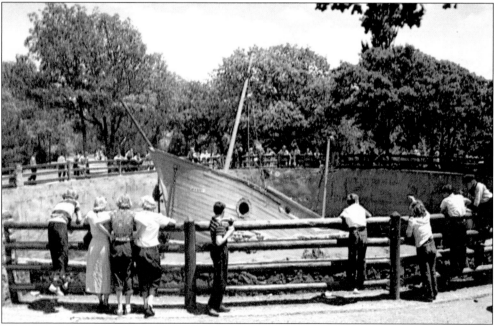

In the 1930s, oil man Frank Phillips donated two brown bears to the zoo. One of them, Frankie, became Barbecue Bear's mate, and they sired two cubs, Flip and Flop. Leo Blondin invited famed wildlife photographer Martin Johnson to take pictures of Flip and Flop. This photograph, although similar, is not believed to be Johnson's work since it features Blondin holding a black bear cub. (Oklahoma City Zoo.)

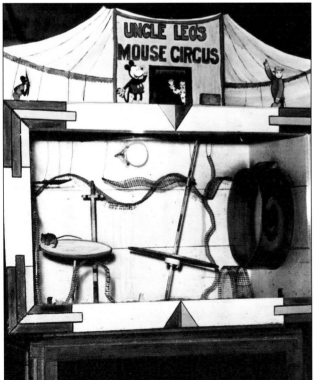

A mouse circus was one of Lincoln Park's rarities. An old friend of Blondin sent him the wooden, handmade circus as a present in 1935. The revolving platform, maze, and spinning wheel held 15 mice. The performing mice were simply captured on zoo grounds as needed, but they quickly adapted to life on the miniature stage. (Copyright 1935, the Oklahoma Publishing Company.)

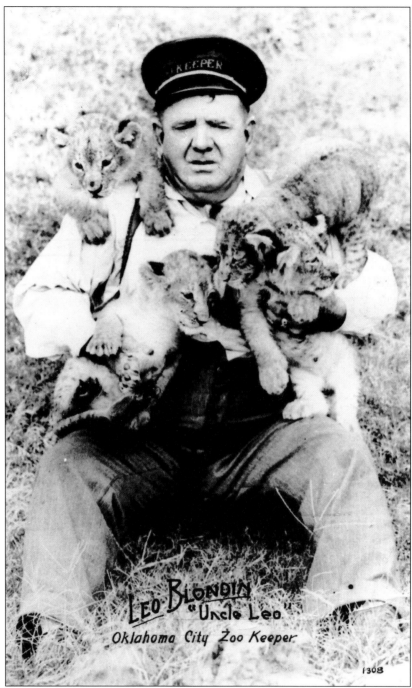

This postcard, sent to Uncle Leo Club members in 1935, shows Leo Blondin with one of Queenie's many lion litters. Queenie, sometimes called the Lion Queen, often helped the zoo when economic trouble struck. Her offspring were considered more valuable than most lions because their eyelashes were longer and their teeth were "pearlier." Blondin often sold or traded her babies for twice the value of an average lion, and many of the zoo's animals came to Lincoln Park as part of a trade for one of Queenie's cubs. (John Dunning Collection.)

In the late 1930s, an elk named Montana escaped from Lincoln Park. After swimming across Northeast Lake, he scared golfers as he dashed across the fairway. The elk chose to spend the night with a herd of cows at a nearby dairy farm. Then, a week later, Montana appeared again, three miles away. Zoo staff finally recaptured him by building a live trap filled with goodies. (John Dunning Collection.)

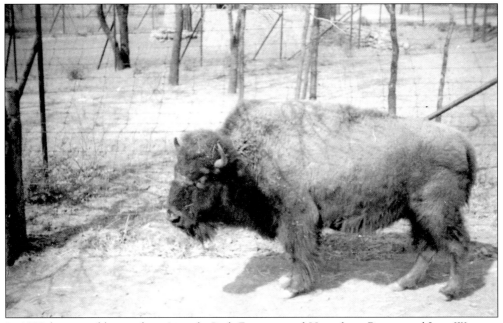

In 1939, bison and horses from Lincoln Park Zoo escorted Humphrey Bogart and Jane Wyman, filling in for Rosemary Lane, to the world premiere of *Oklahoma Kid*. The movie depicted the true story of a gangster cowboy during the land run. Wiley Post Park was transformed into a frontier camp. Following a western-style barbecue, the actors mounted the zoo's animals for a parade to Criterion Theater for the movie showing. (Ernie Wilson Collection.)

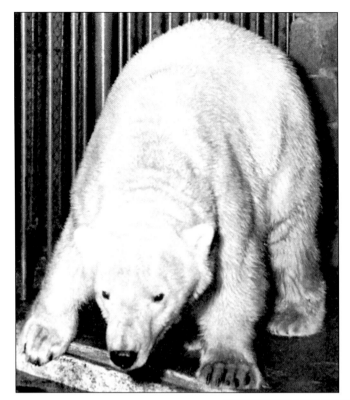

The zoo purchased a 40-year-old polar bear in 1939. His original owner, Kaiser Wilhelm of Germany, brought him to America for the 1903 St. Louis World Fair. Next, a wealthy copper-mine manager owned Carmichael until Leo Blondin traded two yaks for him. Carmichael's original name was Court of Rome, after his birthplace. An Oklahoma reporter decided that name was too formal, so he changed it to Carmichael. (Oklahoma City Zoo.)

Carmichael came to the zoo with a reputation for being dangerous and difficult. The bear, nicknamed "Killer Carmichael," had already sent from three to eight female bears to their death. Two months following his arrival, the polar bear clawed the arm of a teenage boy. The youth unwisely climbed over the guardrail and reached over the five-foot fence so he could pet Carmichael. (Copyright 1939, the Oklahoma Publishing Company.)

Carmichael's stardom in Oklahoma often hinged on the weather. During the blazing summers, he was depicted as miserable, and during winter, he was the epitome of happiness. Whenever it snowed, Carmichael's photograph was likely to appear in newspapers. Zoo officials even began forecasting the winter weather based upon the thickness of his fur each fall. (Ernie Wilson Collection.)

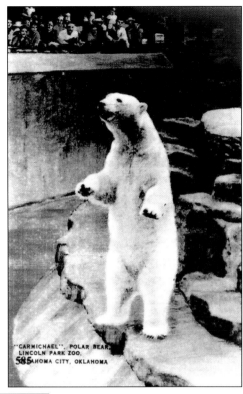

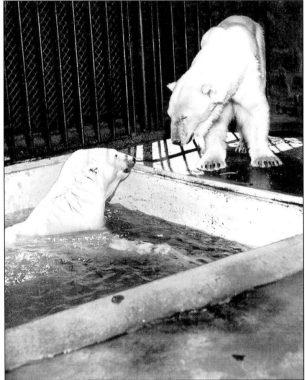

In 1950, the zoo decided to replace the nearly 60-year-old bear with a one-year-old polar bear cub. The public called him Carmichael as well, so the name stuck for another generation of polar bears. In this picture, he is "honeymooning" with his mate Penny. In 1969, Carmichael the Second left, and his replacement, Carmichael the Third, arrived and lived at the zoo into the 1970s. (Copyright 1952, the Oklahoma Publishing Company.)

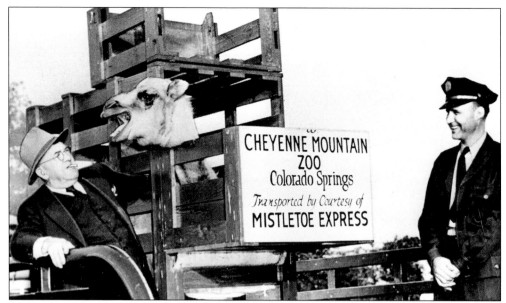

In the 1930s, the Shriners purchased a male camel named India. He and his female mate, Ruby, bore many offspring. Firecracker was born on the Fourth of July 1938, the first camel born to any zoo in 14 years. Patricia was born on St. Patrick's Day 1941. Mistletoe came in 1943, named after the Mistletoe Express Company, a trucking establishment that often transported the zoo's animals. (Oklahoma City Zoo.)

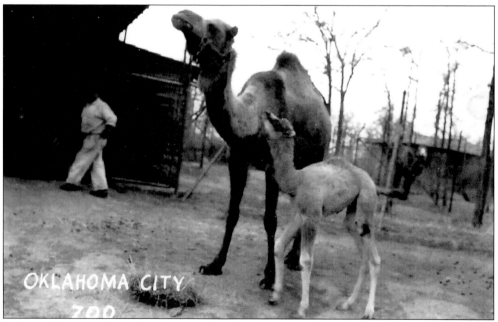

India and Ruby next had a female named Joe C., rather, Josie, because Leo Blondin had promised to name the next camel after Joe C. Campbell, city councilman. Oklahomans anxiously anticipated the fifth baby of India and Ruby, hoping it would be male. In January 1946, the wobbling baby camel named Mungo arrived. It was a boy! (Ernie Wilson Collection.)

Five

LINCOLN PARK ZOO
1940–1949

As in the previous decades, the zoo continued to grow and improve despite economic hardship and war. Oklahomans affected by World War II and its aftermath sought respite at the zoo. They chose to be comforted by the animals and entertained by Leo Blondin. Newspapers wrote whimsical feature stories that distracted citizens' minds from the problems at hand.

During this decade, the Lincoln Park Zoo also became commonly known as the Oklahoma City Zoo, although the name was not officially changed until decades later.

On July 20, 1947, Leo Blondin passed away unexpectedly. The zoo closed for a day in his honor, and many memorials were dedicated to the man who ran the zoo for 17 years. His wife, Eleanor, requested that the Parks Department allow her to continue running the zoo on a trial basis for six months. Because she was a woman, her application was not even considered. Three months later, Lincoln Park hired Julian Frazier.

Frazier, who had been assistant zoo director at the Forth Worth Zoo for 15 years, knew he had big shoes to fill. Like Blondin, he believed it was important to capitalize upon the zoo's number-one audience: children. He spent a great deal of time with the public, helping visitors develop personal relationships with the zoo's animals. Frazier's crowning achievement, however, was his ability to develop animal-purchasing campaigns that involved the entire community. The Oklahoma City Zoo has Frazier to thank for its best-known mascot of all time, Judy the elephant, who came at the end of the decade.

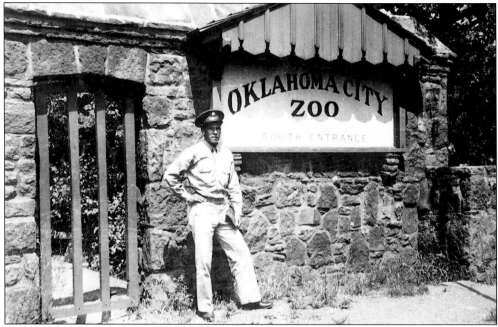

Sgt. Fritz Kuffer stands at the zoo's south entrance in 1942, wearing his Army Air Corps uniform. He spent his last day in Oklahoma City at the zoo with his wife, Betty, before leaving for war duty in Japan. The entryway seen behind Kuffer had been built by the WPA in 1936 and led to the Clara Girvin bridge. (Wes and Lori Allen.)

An army soldier stationed in the jungle exchanged a pack of cigarettes for a Filipino monkey in 1946. The monkey earned the name Trouble since he destroyed the private's living quarters within two days. When the soldier returned and entered law school at the University of Oklahoma, the monkey was sent to Lincoln Park. Leo Blondin and Trouble hit it off and became frequent companions. (Copyright 1946, the Oklahoma Publishing Company.)

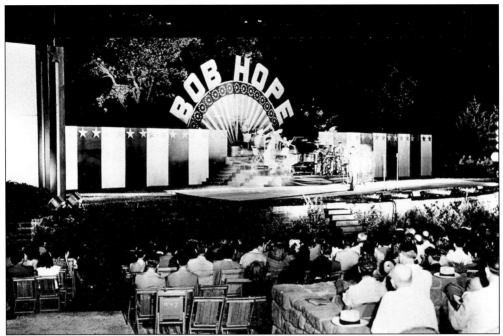

Famous comedian Bob Hope headlined at the zoo amphitheater on October 16, 1946, with his popular radio program, *The Pepsodent Show*. He performed for a crowd of troops and guests from Tinker Air Force Base. (Oklahoma City Zoo.)

In 1946, Sinbad the badger was donated by a visiting farmer. While watching the rodeo, the farmer's car was stolen, along with the badger he intended to give to the zoo. Police sent out a dispatch, and the farmer boarded a streetcar for home. At an intersection, he recognized his vehicle as part of a three-car wreck. The automobile thief had been a 14-year-old boy. (Oklahoma City Zoo.)

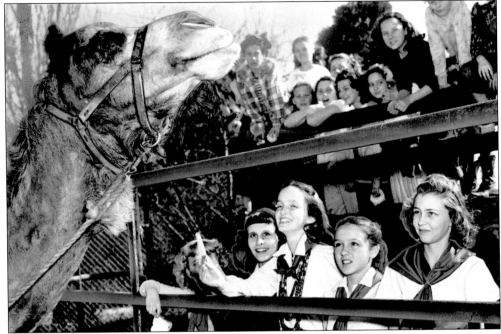

In 1947, a group of Camp Fire Girls came to Lincoln Park for a field trip. These five lucky girls were allowed to feed Ruby the camel through the fence. From left to right are Juanita Benham from Watonga, Eleanor Jane Jacob from Cherokee, Barbara Hall from Medford, Martha Nell Parker from Perry, and Patricia Ann Duggan from Enid. (Copyright 1947, the Oklahoma Publishing Company.)

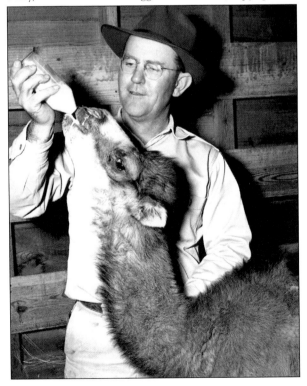

Mistletoe, daughter of Ruby the camel, apparently did not follow her mother's good parenting example. When she became a mother in 1948, she rejected the baby, named Happy. Eventually new zoo director Julian Frazier took on the task of feeding the infant every three hours. (Copyright 1948, the Oklahoma Publishing Company.)

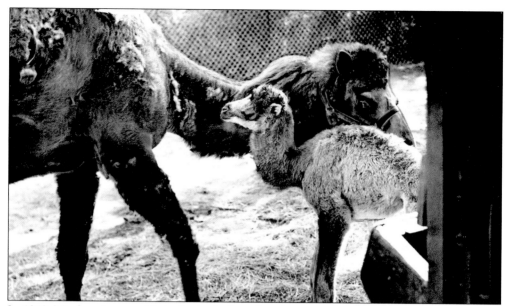

In 1949, Mistletoe's second baby had a bad tendon that caused it to walk on one knee. Again Mistletoe rejected the baby. Zookeepers tried forcing Mistletoe to nurse. Tying her to the fence for a daily milking went badly, and staff feared the little camel was not getting enough nutrients from their homemade mixture. They hand-fed the baby until Mistletoe finally learned to feed the baby herself. (Copyright 1949, the Oklahoma Publishing Company.)

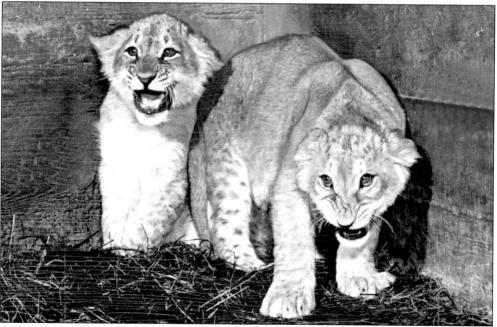

In 1947, animal dealer Louis Goebel recommended that the Metro-Goldwyn-Mayer (MGM) animal department buy some lion cubs from the Lincoln Park Zoo. The California movie studio telephoned Julian Frazier to request that two cubs fly to Hollywood and begin their movie career in an upcoming picture filmed in Germany. Frazier pick the two best-looking cubs from among seven living together in the den. (Copyright 1947, the Oklahoma Publishing Company.)

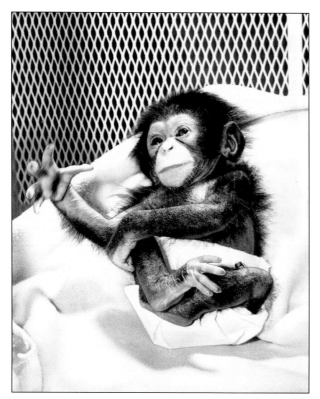

Bill the chimpanzee weighed only two and a half pounds when he was born in February 1949. When Bill's mother became ill and was unable to nurse him four days later, his chances looked slim. Julian Frazier made the decision to hand-raise Bill. Doctors based Bill's health plan on a human baby plan: formula, sleep, a bassinet, and diapers. Within days, Bill's eyes brightened, and he began to kick, cry, and gain weight. (Copyright 1949, the Oklahoma Publishing Company.)

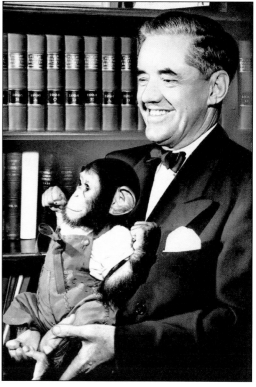

In September, Oklahoma City mayor Allen Street invited the then-healthy Bill to serve as "afternoon mayor" for the day. Bill was dressed in denim overalls and a red bow tie in honor of Mayor Street, whose trademark dress included bow ties. Next he made his television debut on the children's puppet show *The Gismo Goodkin Show.* (Copyright 1949, the Oklahoma Publishing Company.)

Bill's popularity soared as he endured yet another near-death situation. In December 1949, Bill was rescued from a blazing building. An overheated gas stove in the animal barn had set one of the walls on fire. The zoo capitalized on their famous chimpanzee's early trials and rise to fame by featuring him in many zoo advertisements and, later, in a book called *Zoo's Who*. (Copyright 1949, the Oklahoma Publishing Company.)

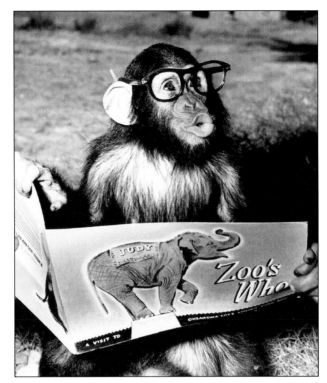

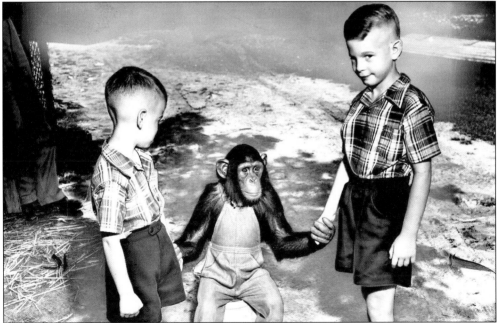

Wearing overalls became Bill's trademark look. Zookeepers often dressed him up for children's parties and other public appearances. Frazier trained Bill in a large repertoire of tricks, which made him an even more popular entertainer. Even though Bill grew too strong to safely interact with the public, he continued to draw a large following of fans. (Copyright 1949, the Oklahoma Publishing Company.)

On February 16, 1949, Luna passed away. The next day, 16-year-old Duane Andrews of Kingfisher, Oklahoma, began raising money to purchase a new elephant. The *Daily Oklahoman* and WKY radio station were already discussing hosting an elephant-purchasing campaign. Duane Andrews beat them to the punch by delivering a $16.73 check to the zoo. The newspaper and the radio station capitalized on the story, and the campaign began immediately. (Copyright 1949, the Oklahoma Publishing Company.)

The zoo printed coupons inviting contributions and name suggestions. Collection boxes were placed in Veazey's Drugstores. The total needed to purchase an elephant was $4,500. Donations began to pour in from all over Oklahoma and even other countries. Daily totals were announced in newspaper headlines, and within 10 days, over half of the money had been raised. (Oklahoma City Zoo.)

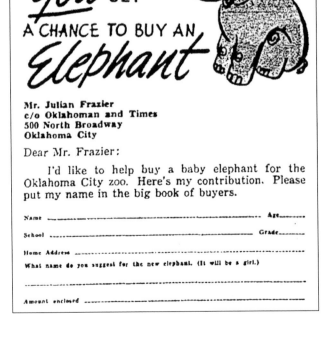

IT ISN'T EVERY DAY *You* GET A CHANCE TO BUY AN *Elephant*

Mr. Julian Frazier
c/o Oklahoman and Times
500 North Broadway
Oklahoma City

Dear Mr. Frazier:

I'd like to help buy a baby elephant for the Oklahoma City zoo. Here's my contribution. Please put my name in the big book of buyers.

Name .. Age

School .. Grade

Home Address ..

What name do you suggest for the new elephant. (It will be a girl.)

..

Amount enclosed ..

The Biltmore Hotel in downtown Oklahoma City designated the lobby as a collection site, shown here. Movie theaters offered free cartoons and a feature of *The Life of Riley* on Saturday morning for children who brought donations for the elephant. Rothschild's Department Store printed T-shirts with the statement "I bought an elephant." From each $1.39 shirt, 10¢ went to the zoo. (Copyright 1949, the Oklahoma Publishing Company.)

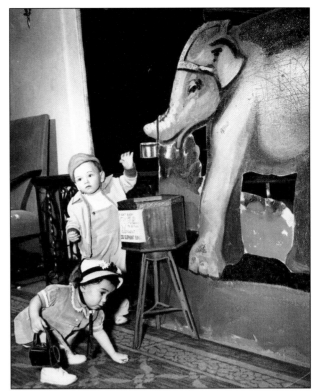

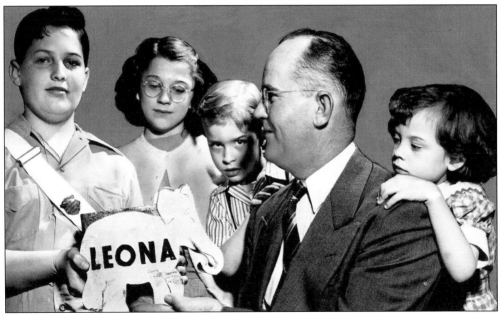

Schoolchildren raised coins and cast their votes for the new elephant's name. Many children sent in their tooth fairy money. Twelve-year-old Jerry Stearman, living at Crippled Children's Hospital with rheumatic fever, sent a silver dollar and suggested the elephant be named Judy in honor of Julian Frazier. Cecil Robinson of Eubanks, Oklahoma, offered to provide hay to feed the elephant for the first 20 days. (Copyright 1949, the Oklahoma Publishing Company.)

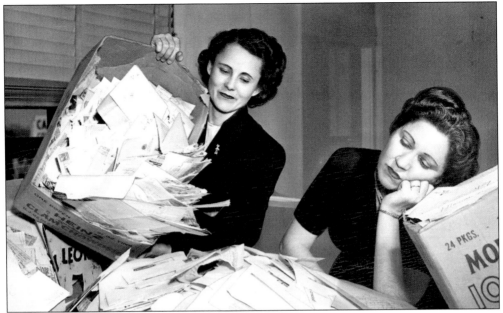

Within two weeks, the $4,500 had been raised, and money was still pouring in. Over 50,000 people sent donations. Two secretaries worked full-time to write down the donors' names and tally name votes. An additional six helpers were hired. Soon the total jumped to $8,000, twice the needed amount. Two seals were purchased with the extra money. (Copyright 1949, the Oklahoma Publishing Company.)

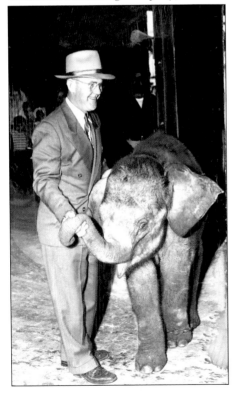

Julian Frazier traveled to Los Angeles to pick an elephant from the latest shipment from India. He picked the one that seemed the most playful, even though she only weighed 950 pounds. This picture of the two meeting each other ran in Oklahoma newspapers, even though the baby elephant stayed at the Fort Worth Zoo until her welcoming parade on May 21, 1949. (Copyright 1949, the Oklahoma Publishing Company.)

ELEPHANTS AREN'T A *Dime* A DOZEN — BUT *Dimes* ~~WILL BUY ONE~~ BOUGHT THIS ONE

Hello there!

The City of Oklahoma City would like for the children of your city to be its guests May 21.

Come and help us welcome Oklahoma's new baby elephant! It was purchased by the children of the state and has traveled all the way from distant Siam to delight the hearts of the kiddies.

There is to be a grand parade headed by the baby elephant! There is to be a six foot birthday cake in the parade! There is to be the unveiling and the naming of the elephant! Bring your bands. Bring your busses. Join the big parade. Help us make this a day for the children to remember.

You are to unload the children at First and Walker Streets on Couch Drive not later than 10:30 the morning of May 21. Your city will be given a position in the parade. You will then drive your bus or other vehicle to North Broadway and 13th Streets and wait to receive the children so they will have transportation to Lincoln Park Amphitheatre at North Eastern and Northeast 42nd Streets for the final program of the day. The parade will begin promptly at 12:30.

Please let your town know about this gala celebration. If possible let us know how many bands and how many busses you expect to send. Let us have this information not later than May 16.

We'll see you on elephant day,

H. H. Clifford, Jr.

H. H. Clifford, Jr.
Chairman of Elephant Committee

HHCjr.:RRM:ob

Plans were made for the welcoming parade. School bands were invited to perform, with Kingfisher High School leading the parade in honor of Duane Andrews. A six-foot-tall birthday cake was ordered, and Crippled Children's Hospital was notified that the elephant would be driven past the courtyard for patients to see. However, trouble was brewing in Fort Worth. Days before the parade, Texas had torrential rains that left the zoo four feet underwater. Frazier traveled with a delivery truck down the hazardous route to rescue the baby elephant. Police officers allowed him entry onto the dangerous roads leading to the zoo. The ride back to Oklahoma City was uneventful, although many motorists were surprised to see an elephant's trunk waving to them from out of the side of the cargo holder. Two days before the parade, she was secretly moved into a barn at her new home in Lincoln Park. (Oklahoma City Zoo.)

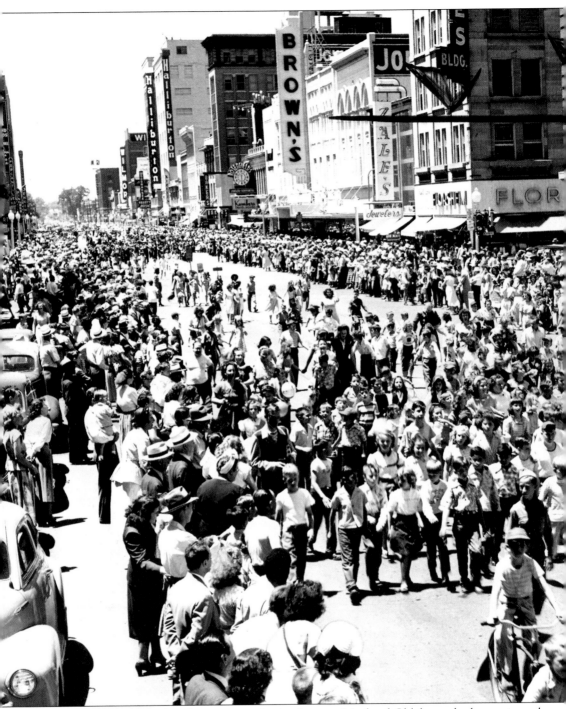

May 21, 1949, dawned with warnings of rain showers. Much of Oklahoma had experienced devastating tornados overnight. Fortunately the rain held back, and an estimated 40,000 people showed up for the elephant parade. Police officers and Boy Scouts struggled to keep excited children from climbing onto the Riss and Company flatbed truck as it rolled downtown. No other cars were allowed on the parade route, and traffic jams erupted throughout the city. At the

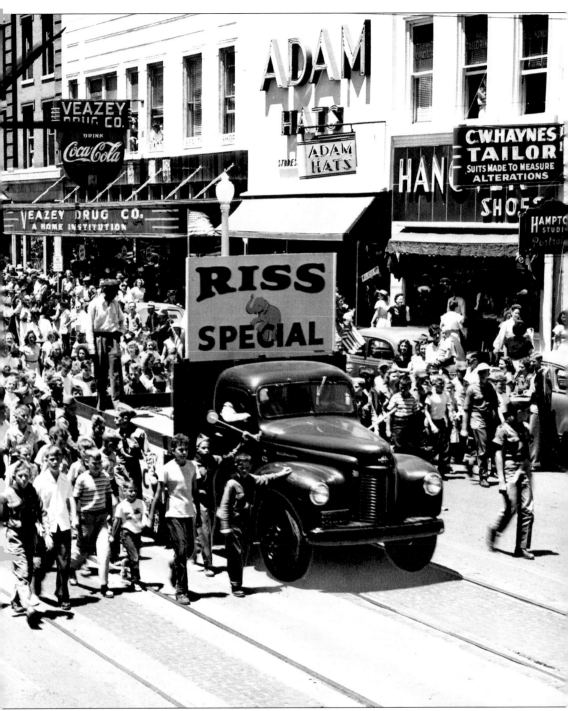

end of the parade, children boarded Oklahoma Railway Company buses to travel to the zoo's amphitheater. Patients in beds and wheelchairs lined the courtyard fence of Crippled Children's Hospital to catch a glimpse of the elephant as she made a special pass by the hospital. (Copyright 1949, the Oklahoma Publishing Company.)

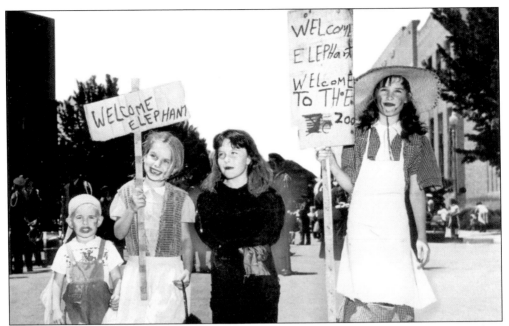

Children turned the day into a holiday, donning costumes and carrying signs to welcome their new elephant. At the amphitheater, Mayor Allen Street thanked the 50,000 donors. Next, Duane Andrews unveiled the sign revealing the name that won the most votes—Judy. Finally the throng of children streamed out of the amphitheater to get cake before rushing back to get another look at their elephant. (Copyright 1949, the Oklahoma Publishing Company.)

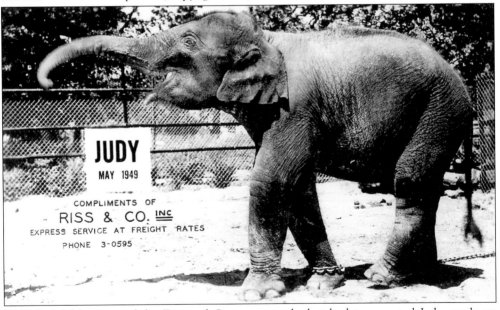

E. E. Stohfield, owner of the Riss and Company truck that had transported Judy, made an announcement in the amphitheater that everyone who wrote in a request would be mailed a postcard snapshot of the new elephant. His generous offer was mainly to accommodate the children who were unable to attend the parade because of hometown flooding. Within days, over 12,500 letters piled into his office. (John Dunning Collection.)

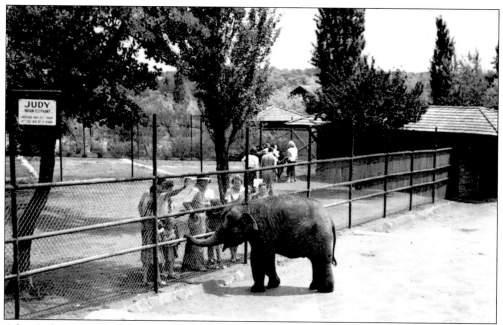

After Judy's arrival, the zoo was a flurry of activity—over 66,000 fans came to see the new elephant. They bought gallons of Judy Cola, a drink sold in her honor, and gathered around the four ledgers of donors' names. Keepers took turns helping children find their names in the leather-bound books. Visitors did not want to leave at closing time, and police officers were dispatched to help with traffic around the zoo. Despite the nonstop crowds at her fence, Judy remained calm and did not seem to mind the attention. She spent most of the days going up and down the fence, sniffing each child in turn. (Ernie Wilson Collection.)

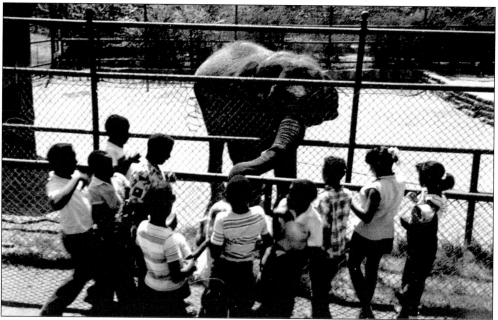

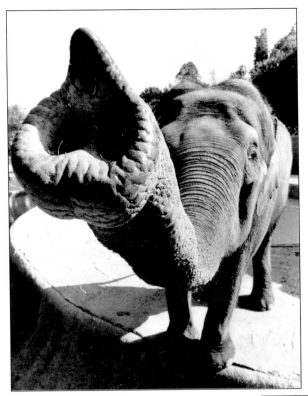

Judy had no fear of cameras. One photographer was allowed into her yard to take photographs during her second week at the zoo. Judy waved her snout and walked right over to the man. Every time he tried to snap the shutter, she ran her wet trunk over the lens. The problem was finally solved by giving her some apples, her favorite treat, to munch on. (Oklahoma City Zoo.)

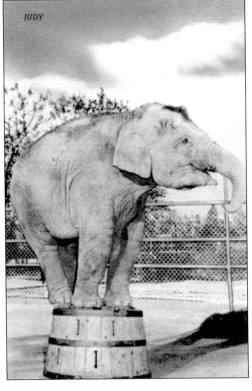

Julian Frazier quickly began training Judy in a repertoire of tricks. Within weeks of her arrival, she could stand on a barrel and do a round-and-round dance. Keepers claimed that they could not take credit for the act, because she came up with the dance on her own in order to get an apple. The pose was photographed and turned into a much-circulated postcard of the famous new elephant. (Ernie Wilson Collection.)

From the beginning, Frazier intended for Judy to give children rides on her back. The training started early, and she adjusted to it quickly. Although Judy did not mind being ridden on, not all children felt as comfortable with the idea. Tommy Cain complained to animal trainer Bert Pettus that Judy swayed too much, while other children reacted to the ride with great joy and excitement. (Copyright 1951, the Oklahoma Publishing Company.)

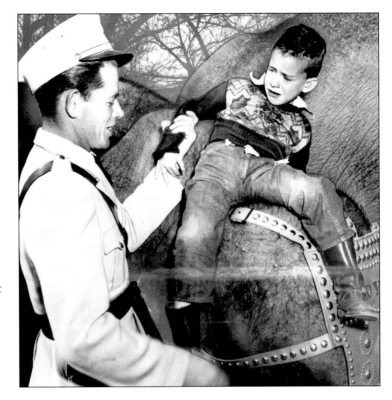

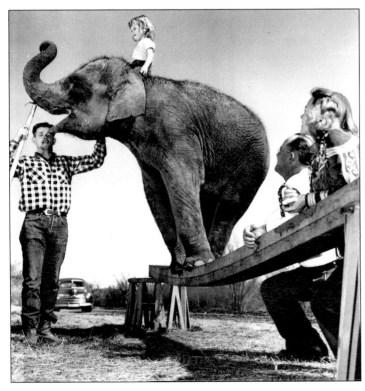

Bert Pettus was Judy's teacher from Perry, Oklahoma, where she attended obedience school. She received high compliments for being a quick learner and calm around people, although she tended to squirt them with her trunk. Pettus taught Judy a routine she performed often: walking a narrow plank from one end to the other. The trainer's daughter, Sandra, rides on Judy's back while Frazier and Mrs. Pettus watch. (Copyright 1951, the Oklahoma Publishing Company.)

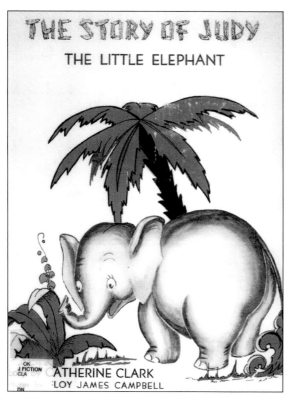

In 1950, Judy became the character in a children's book by Catherine Clark. The fictionalized book, *The Story of Judy the Little Elephant*, told about her travel to America. On the back page of the book was a life-sized footprint of Judy's foot. (Oklahoma City Zoo.)

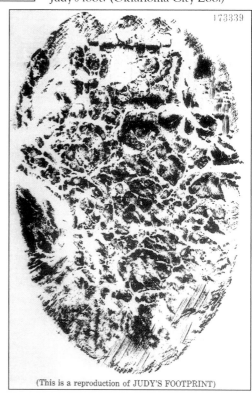

(This is a reproduction of JUDY'S FOOTPRINT)

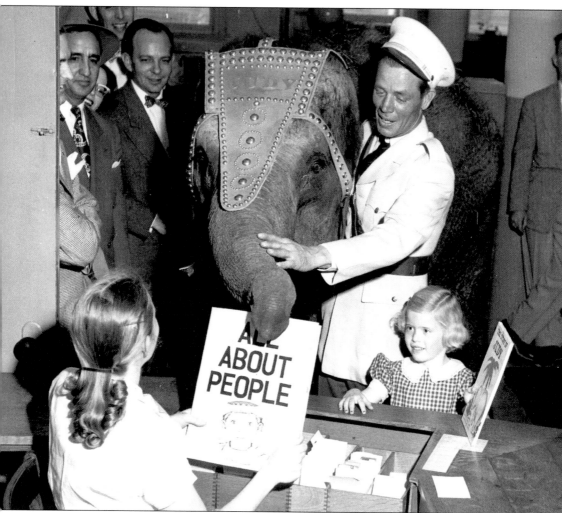

Judy helped publicize her biography in a series of book signings and media events. On March 22, 1951, she visited the Downtown Metropolitan Library System with her trainer, Bert Pettus. Librarian Jean Babcock issued Judy a library card. This photograph, still hanging at the library, shows a little girl checking out a copy of *The Story of Judy the Little Elephant*. In turn, Judy checks out a book about people. (Copyright 1951, the Oklahoma Publishing Company.)

Now, Just in Time for Her Birthday Party ...

The Story of Judy

The Little Eelephant

Thrill your youngsters with this gay, easy-to-read saga, telling about Judy's purchase with the pennies of Oklahoma school children and her clever antics that make her the "pet of the zoo." It's colorfully illustrated, appealing to children everywhere, and particularly to those who know and "own" Judy.

1.25

This delightful "Story of Judy" on records,
narrated by Neta Kaye Stokely ----------------1.50

Catherine Clark, author of "The Story of Judy."

Floy-James Campbell, illustrator of The Story of Judy.

Neta Faye, Stokely, narrator of record "The Story of Judy."

Autographing Party!

Saturday, May 27th, 11 a.m. to 4 p.m.
with "Judy" Footprint, Balloon Prizes

Catherine Clark, author of the book
Floy James, Campbell, illustrator
Neta Kaye Stokely, narrator of record

Book Dept., 2nd Floor, 1st Street
Capitol Hill, Street Floor

Hey, Kids! You Will Want To

Wear a Judy T-Shirt

to her birthday party, Sunday, May 28th

Honor Judy by wearing this cool cotton knit shirt with her picture on the front! Choose yours in white, grey, blue, maize . . . all with washable, color-fast picture print, short sleeves. It's a practical shirt to wear all Summer with jeans and slacks. Sizes 2 to 14.

1.00

The Story of Judy the Little Elephant was released just in time for Judy's first official birthday party at the zoo. The autographing party, held on May 27, 1950, featured all three contributors to the book plus an opportunity to purchase Judy T-shirts for the next day's party. The book, written by Catherine Clark, was illustrated by Fly James Campbell and narrated onto a record by Neta Faye Stokely. Judy's book sold for $1.25, and the record sold for $1.50. (Oklahoma City Zoo.)

Judy's first birthday party was held on May 28, 1950. Dan James, a chef at the Biltmore Hotel, baked a replica of the six-foot birthday cake he had made at Judy's welcoming parade the year before. Mayor Allen Street and a number of sponsors helped pay for the party, which was televised by WKY-TV. Riss and Company brought in a platform stage for Julian Frazier's welcoming speech and various dance performances by children. (Copyright 1950, the Oklahoma Publishing Company.)

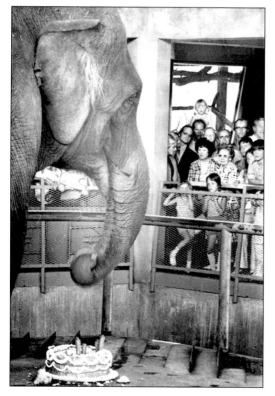

Judy's birthday party became an annual tradition, complete with free cake and ice cream. It was always held around May 21, to celebrate the date she came to live at the zoo. Thousands of children, and eventually adults, who had grown up with Judy, came for the annual event. (Copyright 1974, the Oklahoma Publishing Company.)

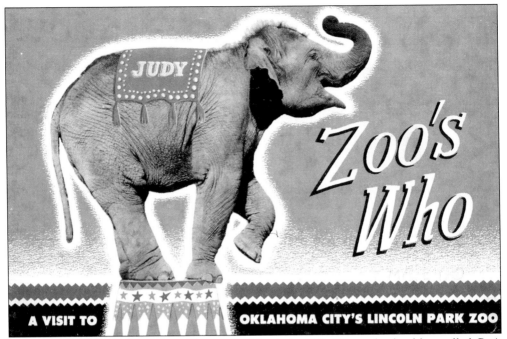

Judy was featured on the cover of her second book in 1951. The color booklet, called *Zoo's Who: A Visit to Oklahoma City's Lincoln Park Zoo*, introduced readers to the zoo's most famous residents, including Bill the chimpanzee and Heiner Ord the bear. (Oklahoma City Zoo.)

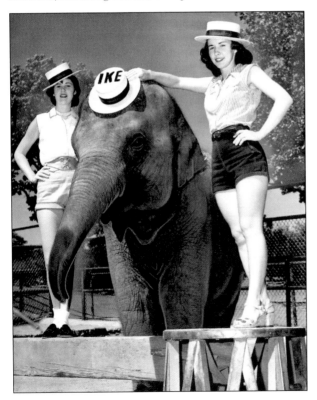

During election years, Judy was often called upon to serve as the mascot for the Republican Party. In 1952, she wore an Ike hat to bolster the campaign for Pres. Dwight D. Eisenhower. (Copyright 1952, the Oklahoma Publishing Company.)

Over the years, Judy learned to perform a wide range of behaviors, which were always popular with crowds. On several occasions, she was sent away to circus training school to improve her skills. Judy always earned high praise and good grades for her schoolwork. Upon her return, a parade would be held to welcome her home. She would then hold special performances to demonstrate her new abilities. (Oklahoma City Zoo.)

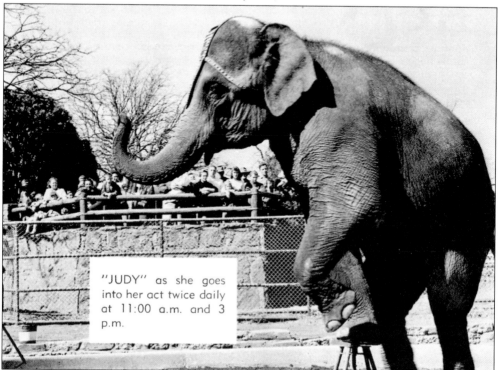

"JUDY" as she goes into her act twice daily at 11:00 a.m. and 3 p.m.

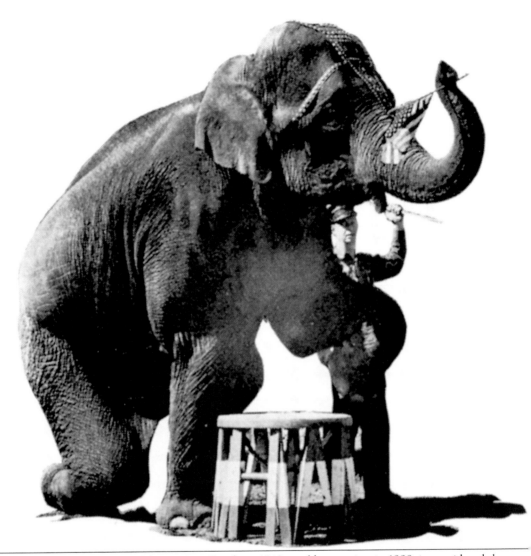

Judy, who lived at the Oklahoma City Zoo from 1949 until her passing in 1998, is considered the zoo's most tremendous ambassador, entertainer, and educator of all time. Not only did she make a grand entrance, she continued to delight zoo visitors for nearly 50 years. She was featured in numerous books, advertisements, and countless television shows. What made Judy most special was that she was owned by so many children, who still remember her fondly as "the elephant I bought for the Oklahoma City Zoo." (John Dunning Collection.)

Six

LINCOLN PARK ZOO
1950–1959

Some of the most entertaining characters in the zoo's history came from this decade, including Leapy the leopard and Mathilda the hippopotamus. Zoo director Julian Frazier excelled at getting citizens excited about improving their community during a time when citizenship and family life held highest priority. Frazier, much like his predecessor Leo Blondin, believed that the zoo brought value to Oklahoma City as an entertainment venue.

He also assured war-wary people of their safety. If an air raid occurred in Oklahoma City, the zoo's most dangerous animals would be safely locked into their underground caves, surrounded by heavy concrete.

Frazier and park superintendent R. R. "Pat" Murphy worked closely together to bring improvements to the zoo. In 1951, they undertook a project to add paved roads around the zoo's perimeter. Walkways within the zoo were repaired for the first time since the early 1940s, and terms were negotiated to make the zoo's toy train more profitable.

Frazier strove to add variety to the collection. Following his success with the 1949 Judy the elephant campaign, he embarked upon other animal-purchasing fund-raisers. He used his newly found talent to devise contests that compelled children to send their pocket change to buy everything from giraffes to apes. Many of these sought-after animals received daily press coverage, and some made national and international headlines. Rarely a day passed in the 1950s that Lincoln Park was not featured in several local newspaper articles—even if it was a simple paragraph about some out-of-town children visiting the zoo.

The most significant event of the decade occurred in February 1950, when a leopard escaped from its grotto and roamed the city for three days. Headlines around the world portrayed Oklahoma City as the scene of mass chaos. Ironically the leopard's mate escaped three years later, although the situation was handled quickly and with less media attention.

Another newsbreak for the zoo occurred in December 1953. The hit song "I Want a Hippopotamus for Christmas" resulted in children purchasing a live hippopotamus for Lincoln Park. Citizens of the 1950s truly had ownership in their zoo and felt personally connected to the animals living there.

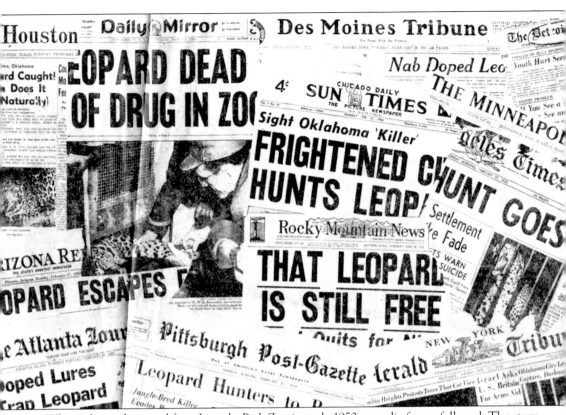

When a leopard escaped from Lincoln Park Zoo in early 1950, a media frenzy followed. The story made international headlines, the front page of the *New York Times*, and a five-page spread in *Life Magazine*. This sample collage of newspaper headlines from around the United States ran in the *Daily Oklahoman* on March 5, 1950. (Copyright 1950, the Oklahoma Publishing Company.)

Leopard, Oklahoma City Zoo

The drama began on Saturday, February 25, 1950, when a 200-pound leopard sprang to the top of his exhibit fence, balanced a moment, and then disappeared between some nearby rocks and shrubs. Only a week before, Luther and Lil, two newly captured leopards from India, had arrived at Lincoln Park. They had nearly escaped from a 12-foot-deep grotto, so workers moved them into an 18-foot-deep grotto. Crowds flocked to the exhibit to see the new cats but left disappointed because the leopards chose to hide. (Above, Ernie Wilson Collection; below, copyright 1950, the Oklahoma Publishing Company.)

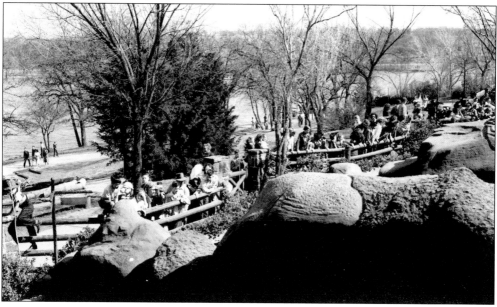

Six young boys witnessed the male cat's escape as he balanced on the fence not 10 feet away from them. The panicked boys ran to set the alarm, but zoo visitors thought they were joking. The boys raced to the house of the zoo's maintenance man, located on the Lincoln Park grounds. He grabbed a .22 rifle, telephoned director Julian Frazier, and headed for the zoo. (Copyright 1950, the Oklahoma Publishing Company.)

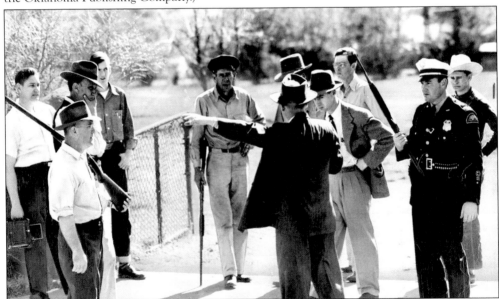

Zoo officials alerted Oklahoma City that the leopard, nicknamed Leapy, had escaped. Zookeepers, police, sheriff deputies, highway patrolmen, and members of the marine reserve battalion gathered to help in the hunt. An army helicopter flew overhead, and tracking dogs were flown in from various states. The Red Cross declared the event as a disaster area. The National Guard and civil air patrol planes added their manpower to the search. (Copyright 1950, the Oklahoma Publishing Company.)

Hundreds of volunteers arrived to help. By Monday, headlines pleaded with civilians, hunters, and sightseers to stay away. So many curious, gun-toting volunteers wanted to be a part of the excitement that traffic jams developed on roads leading to the zoo, and bridges swarmed with spectators. An estimated 3,000 people came to observe. One spectator said, "If they locate the leopard, it'll probably be found trampled to death." City officials called for the withdrawal of all dogs in the area except for the official hunting hounds. They also requested that the heavily armed spectators put away their guns, which ranged from .22 rifles, elephant guns, pistols, army rifles, and shotguns to children's cap guns. (Copyright 1950, the Oklahoma Publishing Company.)

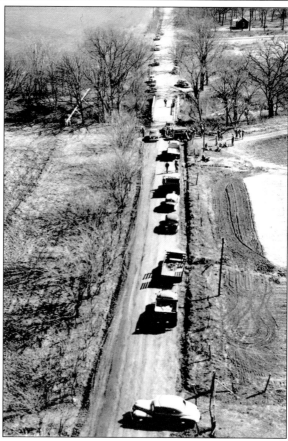

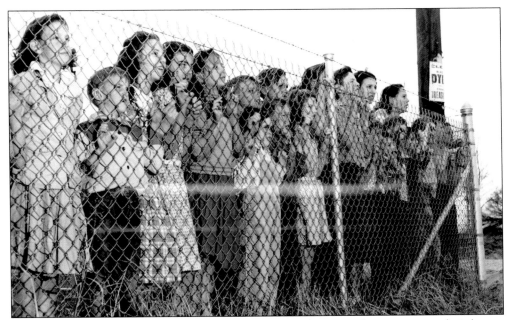

Newspapers depicted the hunt in various ways, ranging from people cowering in their homes in fear to excited celebrations held in the street. School attendance in the area was down, and many parents escorted their children to class. Some schools held recess indoors, but at others, children lined the fences, hoping to catch a glimpse of the escaped cat. (Copyright 1950, the Oklahoma Publishing Company.)

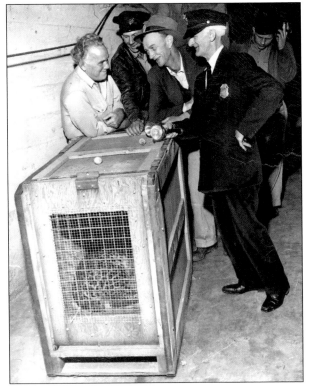

Monday night, after 60 hours, the drama ended. The leopard returned to the zoo around midnight, ate the drugged meat left in his den in case he returned, and passed out. Zookeepers put him in a shipping crate until he recovered, but late Tuesday, he passed away after a veterinarian gave the cat a stimulant to bring him out of his drugged state. Only then did Oklahomans express sadness at the leopard's death. (Copyright 1950, the Oklahoma Publishing Company.)

Oklahoma attorney general Mac Q. Williamson requested that everyone who was part of the leopard hunt be issued identification cards stating "Oklahoma City Leopard Catcher Extraordinaire" as mementos to be passed down through family history. These patches of black and yellow felt were also given out. (Ernie Wilson Collection.)

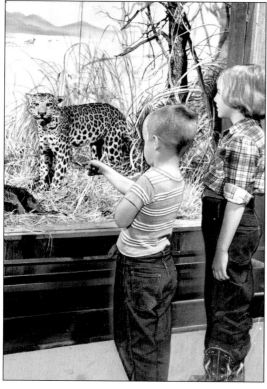

Leapy continued to make headlines as officials decided to have a taxidermist prepare his body for display. The taxidermist's 12-year-old son rounded up his friends and told them that they could pay 5¢ to watch his father at work; however, the children were allowed to look on for free during the two-month process. Leapy's mount was displayed in the old concession building at the zoo for many years. Bobby and Ruth Rice were allowed a sneak peek at the exhibit before it opened on April 22, 1951. (Copyright 1951, the Oklahoma Publishing Company.)

The leopard's escape had a large-scale effect on local and national commerce. In addition to the many offers from businessmen to purchase Leapy's body, leopard-print clothing began appearing in the national retail industry. Within four days, Macy's put a stuffed leopard on the market, including one with light-up eyes. Kerr's placed printed leopard T-shirts on sale for $1, quickly followed by C. R. Anthony's and Macy's department stores. (Stage Stores, Incorporated.)

These 1950s visitors are viewing pelicans, spoonbills, and other waterbirds exhibited inside this large flight cage. The aviary, which still exists on zoo grounds, was built in 1947 with money from the Uncle Leo Memorial Fund. In the background, another flight cage can be seen, which is believed to have been built in 1907 and transported from Wheeler Park when the zoo relocated to Lincoln Park. (Oklahoma City Zoo.)

In the 1950s, only men worked in the field of zookeeping. Because of the showmanship atmosphere of the zoo, most of these men were frequently in view of the public. Pictured above from right to left are Carl Windel, keeper; Martie Allen, keeper; H. A. Alsup, commissary; Ray Mayfield, keeper; Hubert Wall, keeper; Vernon Reeves, keeper; John Lord, night keeper; James Ward, keeper; and Lawrence Stevens, laborer. Below are Marvin Crane (left), foreman, and Homer Spikes, trainer. (Oklahoma City Zoo.)

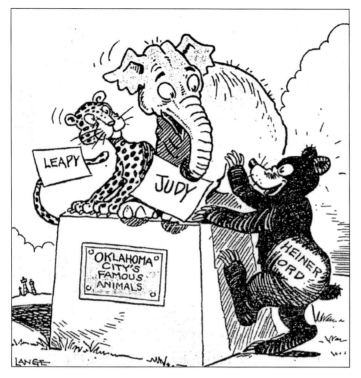

Following World War II, Julian Frazier received a telegram from a Norman, Oklahoma, troop stationed in Japan. It read, "Can you wire soonest if zoo will accept 4-month-old Eurasian brown bear, which division 700th ordinance company wants to give?" The zoo decided to accept the cub. Lt. G. L. Heiner had given the bear, found in Hokkaido, to the 45th Division's 700th Ordinance Company. (Copyright August 16, 1951, the Oklahoma Publishing Company.)

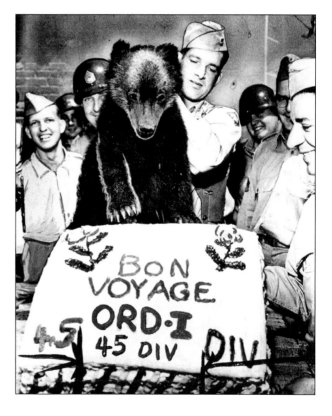

The cub was named Heiner Ord the First, in which Ord stood for ordinance. The 45th Division threw Heiner a bon voyage party. The men made the mistake of putting Heiner on top of a crate to see his large farewell cake. He lunged for the center of the cake, and, to much laughter, the men pulled him back just in time. (Copyright 1951, the Oklahoma Publishing Company.)

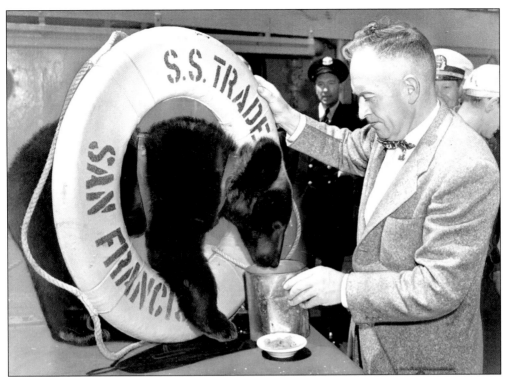

Heiner boarded the SS *Trade Wind*, bound for California, in 1951. When he arrived in Oklahoma in July, via the Santa Fe Railroad, Oklahoma greeted the bear with a large welcoming sign on his exhibit that read, "Privt [sic] Heiner Ord, 45th division mascot, gift of the 700th Ordinance Company to the Lincoln Park Zoo, Oklahoma City, 1951." (Copyright 1951, the Oklahoma Publishing Company.)

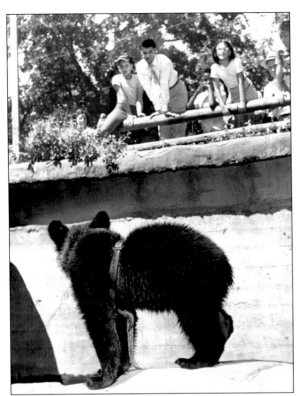

Heiner remained a longtime favorite at the zoo, and he delighted visitors with his tricks and antics. In 1957, the 45th Infantry requested that its bear be present for the dedication of its new armory in Norman, Oklahoma. Heiner Ord, then weighing over 1,000 pounds, had been known to exhibit amazing feats of strength. Frazier suggested that the visitors come visit Heiner at the zoo instead. (Copyright 1951, the Oklahoma Publishing Company.)

This deer paddock exhibited white and black fala, as well as sika and white-tailed deer. Because of its spacious hoofed-animal exhibits and large variety of deer and cattle species, Lincoln Park became world recognized as a zoo specializing in hoofstock. (Oklahoma City Zoo.)

Joe, a pet crow, began visiting the students at Edgemere School in 1952. Every day, he pecked on Kate Balyeat's first-grade classroom window until she let him inside. He would then hop on the children's desks and eat handouts. He preferred peanuts, hamburgers, and red crayons. WKY television station invited Joe and the first graders to appear on its weekly program. (Copyright 1952, the Oklahoma Publishing Company.)

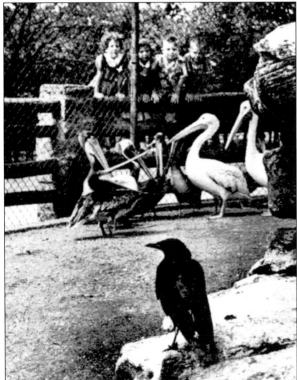

In 1953, police officers got a complaint that Joe had pecked a baby. They went to Edgemere and chased the crow around without success. Since the students defended Joe and cheered when he got away, the officers deputized the class so that they would help catch Joe. The children agreed to a compromise—Joe's life would be spared, but he had to go live at the zoo. (Oklahoma City Zoo.)

113

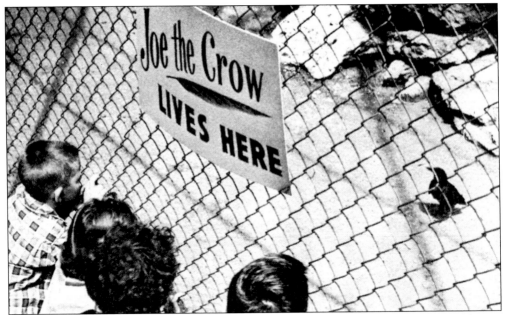

Joe eluded police, however, and was declared a fugitive. Eleven days later, Joe swooped from a tree and spooked a loose horse that police officers were trying to capture. Another month later, a family found Joe and gave him to the zoo. Kate Balyeat discovered that he was a fake, and the real Joe was being hidden. Finally Joe joined his misidentified companion at the zoo. (Stage Stores, Incorporated.)

Marjory Anne Schmid, a writer for WKY's *The Gismo Goodkin Show*, decided that Joe would make a good story, so she wrote a book about his life. The advertising manager of the C. R. Anthony's department stores had a six year old who had followed Joe's story, so he agreed to distribute the book through local stores. A year later, a second book featured Joe's new life at the zoo. (Ernie Wilson Collection.)

114

When Gayla Peevey, a 10-year-old Oklahoma City singer, recorded "I Want A Hippopotamus for Christmas," she found herself as spokesperson for a campaign that would eventually bring a real hippopotamus to the Lincoln Park Zoo—just in time for Christmas! The song sold a record half-a-million copies in December 1953, so Julian Frazier decided to capitalize on the event and grant Peevey's musical request for a hippopotamus. On December 10, he began the Gayla Peevey Hippo Fund. Children were invited to send their pennies to buy a hippopotamus for Peevey, who would then donate it to the zoo. The Oklahoma Publishing Company and WKY-TV kicked off the campaign with $50 each, and Peevey put in her own $1 bill. (Courtesy of SONY BMG Music Entertainment.)

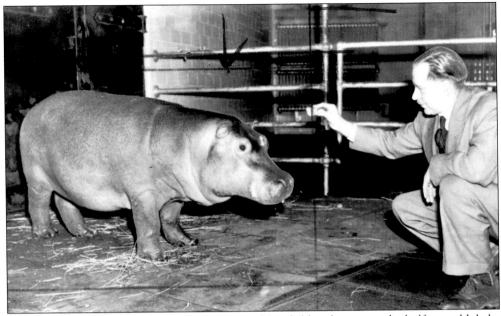

Two days later, newspapers ran this picture of Mathilda, the one-and-a-half-year-old baby hippopotamus Julian Frazier had picked. The 700-pound baby hippopotamus was well traveled. She had been born in Kenya, shipped to Italy, and then sent to New York. The cost of purchasing Mathilda was $3,000 plus the trade of a zebu calf and $500 to fly her to Oklahoma. (Copyright 1953, the Oklahoma Publishing Company.)

'I Want a Hippo for Christmas'

Here's my dime to help the zoo buy it:

Place **Coin** Here

Name

Address

Age

(Those older than 6 can give any amount.)

Mail to Hippo Fund, P. O. Box 8701, Oklahoma City

Daily updates informed the public how much money had arrived for the hippopotamus fund, and donor names were listed in a ledger. The Park Inn Café in Gayla Peevey's neighborhood donated 10¢ every time the song was played on the jukebox. Local schools, including Peevey's own Columbus Elementary, raised money. Peevey performed a second song, "How'd Ja Like to Have a Hippo Christmas Day?" on WKY radio. (Oklahoma City Zoo.)

One week before Christmas, only a third of the money had been raised. Mathilda needed to leave New York on December 23 to arrive by Christmas Eve, but the fund was still short. Apparently Oklahomans felt worried too, because donations arrived just in time. Peevey met the DC-6 cargo plane, ignoring the 16-degree temperature outside. At first sight, she shouted, "She looks like she's all mouth to me!" Two hours later, Peevey climbed on top of the crate and presented Mathilda to Oklahoma City. (Copyright 1953, the Oklahoma Publishing Company.)

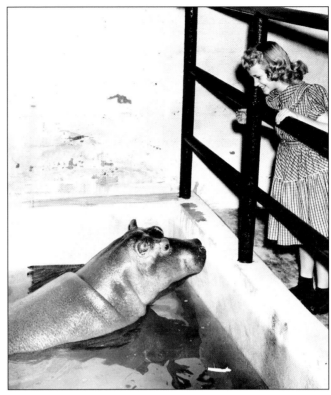

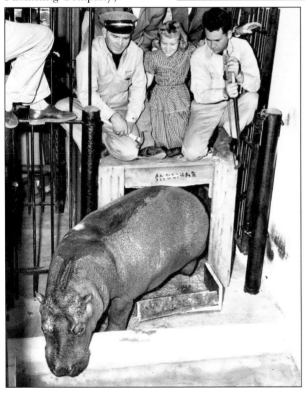

Julian Frazier announced that the zoo would open at 1:00 p.m. on Christmas Day. Over 10,000 people showed up to take the 90-second peek at Mathilda. Crowds lined up for 100 yards, outside in the cold, waiting to squeeze into the small exhibit, which only held 10 to 12 people at a time. (Copyright 1953, the Oklahoma Publishing Company.)

Mathilda's fame did not end there, however. In 1967, she received her own special gift—Norman, a male hippopotamus. The zoo sent colorful invitations to zoo members, inviting them to the formal wedding ceremony on August 8, 1967. (Oklahoma City Zoo.)

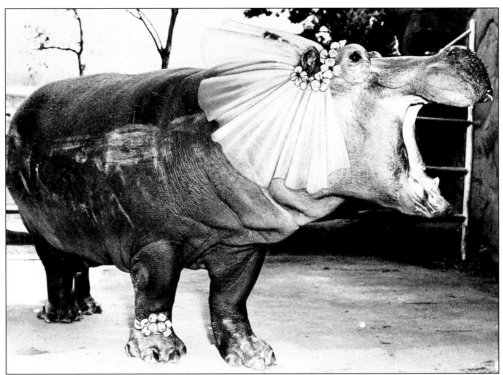

A wedding ceremony for the hippopotamus couple was held, complete with vegetable bouquet and plastic waterproof veil, in case Mathilda decided to take a swim during the event. She and Norman continued to awe zoo visitors for their 31 years together, during which they contributed to the world's precious hippopotamus population by raising nine babies. (Oklahoma City Zoo.)

Just like previous decades, 1950s crowds delighted in the antics of the sea lions. Visitors were invited to watch and participate in the daily feedings. This exhibit, built in 1947 by the Sertoma Club, was complete with winter quarters. The outside pool measured 40 by 50 feet and was 5 feet deep. (Oklahoma City Zoo.)

The Lincoln Park Zoo Reptile Garden opened in 1955, housing over 70 species of reptiles and 20 alligators. A favorite of the visitors was the large Galapagos tortoise exhibit. Bob Jenni, reptile curator, gave daily lectures and educational programs for the public, often about venomous snakes. (Oklahoma City Zoo.)

Bob Jenni delighted in giving zoo visitors up-close experiences with reptiles. In this picture, he carefully holds a poisonous Gila monster so that the children can feel its beadlike scales. (Oklahoma City Zoo.)

In 1955, Alfred the alligator escaped from the reptile house. The 250-pound creature swam in Northeast Lake for three days. Bob Jenni finally shot at the alligator's tail with an arrow attached to a rope. It worked, but Alfred overturned the boat, and Jenni and his helpers feared they would get tangled in the ropes, along with Alfred. Fortunately another canoe crew lassoed Alfred and towed him ashore. (Copyright 1955, the Oklahoma Publishing Company.)

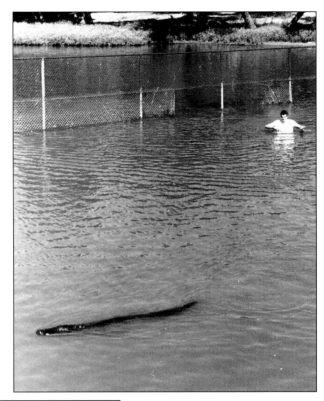

One particularly difficult goat served as the peculiar penalty given to the lowest-revenue-producing train station of the Mid-Continent Freight Lines. When revenues came up, the goat went away—this usually took less than a month! This incentive to make more money, and fast, went on for two years. Finally the freight line donated the well-traveled goat to Lincoln Park Zoo. (Copyright 1958, the Oklahoma Publishing Company.)

The Primate Building was built in the 1950s with a $100,000 bond issue. One side housed chimpanzees, mandrills, and other large primates. The other side housed small tropical monkeys. (John Dunning Collection.)

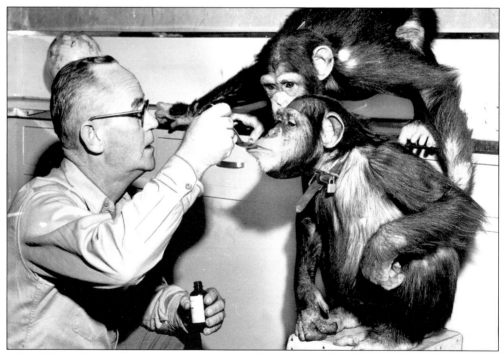

Julian Frazier fed cod-liver oil to two young chimpanzees during the winter months. The popular duo of Minnie and Moe, purchased in 1954, performed a wide variety of tricks and were frequently dressed in costumes for various functions. In 1958, replacement chimpanzees were sought as Minnie and Moe were retired after they became too strong and difficult to be around the public. (Copyright 1956, the Oklahoma Publishing Company.)

In 1959, a dealer offered to sell two orangutans, Mr. Ching and Miss Lotus Blossom, to the zoo. They were valuable because an embargo was passed after the orangutans were shipped, making them the last to be legally exported to the United States. The other 12 orangutans on the same ship had died when a steam pipe broke, scalding them in their cage. (Copyright 1959, the Oklahoma Publishing Company.)

Donors could vote for their favorite orangutan by donating money to either "tame" Mr. Ching or "still-wild" Miss Lotus Blossom. The zoo recorded every person who gave at least $1 in a bound book. Disaster nearly struck when the apes got the flu, and Lotus almost died. In February 1960, the full amount was finally raised, and Ching and Lotus belonged to the zoo. (Copyright 1959, the Oklahoma Publishing Company.)

In August 1957, the zoo was without giraffes. The grandson of Gov. Raymond Gary kicked off a giraffe-buying campaign by having his friends bring money instead of presents to his birthday party. Kurt Austin and Grant Lord went door-to-door collecting money for the giraffe fund. They worried about their 6,000 pennies being stolen, so they called the police station and requested an escort to the zoo. (Copyright 1957, the Oklahoma Publishing Company.)

Other kids invented creative ways of raising pennies for the two new giraffes, from lemonade stands to holding a Tom Thumb wedding. One six-year-old girl sold her drawings by the road for 10¢ apiece. Within a month, half the money was raised. The female, Frieda, arrived via a truck down Main Street and Broadway. It took another year to raise the money for the male. (Copyright 1957, the Oklahoma Publishing Company.)

Lincoln Park rescued a lion from the Oklahoma City Jail in 1959. The owner incarcerated George after he realized George made a poor pet. He took over the apartment and kept crawling into the car and honking the horn. One inmate was glad the newspaper took a picture of the cat, stating that nobody would ever believe he had spent the night in jail with a lion. (Copyright 1959, the Oklahoma Publishing Company.)

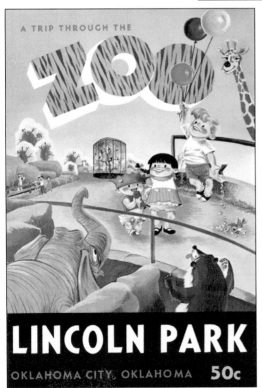

The Lincoln Park Zoo and the Friends of the Zoo partnered to produce a colorful information booklet. In addition to a brief history, readers were introduced to the zookeepers and well-known animals on exhibit at the time, including Heiner Ord, Judy the elephant, and Carmichael the polar bear. (Oklahoma City Zoo.)

The zoo had been trying to hatch a baby ostrich since 1916, but Ida had never succeeded. Henryetta and Horace produced a clutch of eggs in 1959. Horace took the job of guarding the eggs seriously. Keepers used brooms to guard themselves from his attack when they came near. When the first baby ostrich finally hatched, Lincoln Park Zoo had great cause for celebration! (Copyright 1959, the Oklahoma Publishing Company.)

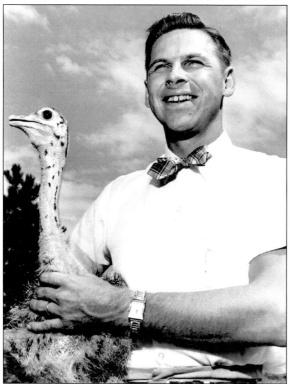

After the baby ostrich's successful entrance into the world, Julian Frazier decided to retire. He passed the torch, and the new ostrich, over to the next zoo director, Dr. Warren Thomas, who served the Lincoln Park Zoo into the 1960s. (Copyright 1959, the Oklahoma Publishing Company.)

BIBLIOGRAPHY

Brooks, Frank G. *Animal Studies in The Oklahoma City Zoological Garden: Official Guide Book.* Oklahoma City, OK: Oklahoma City Parks Board, 1931.

Capitol Hill News, "Greatest Flood in History of North Canadian River," October 18, 1923.

Clark, Catherine. *The Story of Judy the Little Elephant.* Oklahoma City, OK: Bond Publishing, 1950.

Curtis, Lawrence. "The OKC Zoo is 80 Years Young." *Zoosound.* Winter 1984, 6–15.

Despain, S. Mathew. "From Menagerie to Modern Zoo: Nature, Society, and the Beginning of the Oklahoma City Zoo." *Chronicles of Oklahoma* 83, no. 3 (Fall 2005).

Life Magazine, "Great Leopard Hunt," March 13, 1950, 35–39.

Myers, Anna. *Spotting the Leopard.* East Rutherford, NJ: Puffin Press, 1996.

———. Interview conducted by Amy Dee Stephens, via telephone, October 7, 2003.

Oklahoma City Zoo Now and Then: Includes Favorite Animals from the Zoo's History. Terrell Creative, 2004.

Oklahoma City Zoo Scrapbook Collection, 1945–2003. Oklahoma City Zoo Library.

The Oklahoma Publishing Company, 1902–1960. Under titles of *Daily Oklahoman*, 1902–2003, and *Oklahoma City Times*, 1947–1960.

Schmid, Marjory Anne. *Joe the Crow.* Oklahoma City, OK: C. R. Anthony department store, 1953.

———. *Joe the Crow at the Zoo.* Oklahoma City, OK: C. R. Anthony department store, 1953.

Smith, David R. "The Walt Disney Archives: It all started with a mouse." *Historical Journal of Film, Radio, and Television* 16 (1996): 13–18.

DISCOVER THOUSANDS OF LOCAL HISTORY BOOKS FEATURING MILLIONS OF VINTAGE IMAGES

Arcadia Publishing, the leading local history publisher in the United States, is committed to making history accessible and meaningful through publishing books that celebrate and preserve the heritage of America's people and places.

Find more books like this at
www.arcadiapublishing.com

Search for your hometown history, your old stomping grounds, and even your favorite sports team.

‸nsistent with our mission to preserve history on a local level, ‸k was printed in South Carolina on American-made ‸ufactured entirely in the United States. Products ‸ited Forest Stewardship Council (FSC) label 0 percent FSC-certified paper.

127

MADE IN THE USA